I

england and
its aesthetes
biography
and taste

Critical Voices in Art, Theory and Culture
A series edited by Saul Ostrow

Now Available

Forthcoming Titles

john ruskin
walter pater
adrian stokes

essays

england and
its aesthetes

biography
and taste

commentary
david carrier

G+B
ARTS
INTERNATIONAL

Australia · Canada · China · France · Germany · India · Japan · Luxembourg · Malaysia
The Netherlands · Russia · Singapore · Switzerland · Thailand · United Kingdom

Copyright © 1997 OPA (Overseas Publishers Association) Amsterdam B.V.
Published in The Netherlands under license by G + B Arts International.

Selection from *Praeterita* by John Ruskin was taken from *The Works of John Ruskin, M.A.* (New York: Thomas Crowell, 1886–1900).

"The Child in the House" by Walter Pater is reprinted from Walter Pater, *Miscellaneous Studies. A Series of Essays* (London: Macmillan, 1901).

Inside Out by Adrian Stokes is reprinted from *The Critical Writings of Adrian Stokes*. Vol. II. 1937–1958 (London: Thames and Hudson, 1978) by permission of the Adrian Stokes Estate, copyright © 1978 the Adrian Stokes Estate.

Amsteldijk 166
1st Floor
1079 LH Amsterdam
The Netherlands

British Library Cataloguing in Publication Data

Ruskin, John, 1819–1900
 England and its aesthetes : biography and taste.—
 (Critical voices in art, theory and culture)
 1. Ruskin, John, 1819–1900 2. Pater, Walter, 1839–1894
 3. Stokes, Adrian, 1902–1972 4. Aestheticians—England—Biography
 I. Title II. Pater, Walter, 1839–1894 III. Stokes, Adrian, 1902–1972
 IV. Carrier, David, 1944–
 701.1'7'0922'42

 ISBN 90-5701-291-X

For
Paul Barolsky, Bill Berkson and William O'Reilly

Ah qual poter, oh Dei!
donaste alla beltà

—Mozart, *La clemenza di Titto*

CONTENTS

C *ritical Voices in Art, Theory and Culture* is a response to the changing perspectives that have resulted from the continuing application of structural and poststructural methodologies and interpretations to the cultural sphere. From the ongoing processes of deconstruction and reorganization of the traditional canon, new forms of speculative, intellectual inquiry and academic practices have emerged which are premised on the realization that insights into differing aspects of the disciplines that make up this realm are best provided by an interdisciplinary approach that follows a discursive rather than a dialectic model.

In recognition of these changes, and of the view that the histories and practices that form our present circumstances are in turn transformed by the social, economic, and political requirements of our lives, this series will publish not only those authors who already are prominent in their field, or those who are now emerging—but also those writers who had previously been acknowledged, then passed over, only now to become relevant once more. This multigenerational approach will give many writers an opportunity to analyze and reevaluate the position of those thinkers who have influenced their own practices, or to present responses to the themes and writings that are significant to their own research.

In emphasizing dialogue, self-reflective critiques, and exegesis, the *Critical Voices* series not only acknowledges the deterritorialized nature of our present intellectual environment, but also extends the challenge to the traditional supremacy of the authorial voice by literally relocating it within a discursive network. This approach to texts breaks with the current practice of speaking of multiplicity, while continuing to construct a singularly linear vision of discourse

that retains the characteristics of dialectics. In an age when subjects are conceived of as acting upon one another, each within the context of its own history and without contradiction, the ideal of a totalizing system does not seem to suffice. I have come to realize that the near collapse of the endeavor to produce homogeneous terms, practices, and histories—once thought to be an essential aspect of defining the practices of art, theory, and culture—reopened each of these subjects to new interpretations and methods.

My intent as editor of *Critical Voices in Art, Theory and Culture* is to make available to our readers heterogeneous texts that provide a view that looks ahead to new and differing approaches, and back toward those views that make the dialogues and debates developing within the areas of cultural studies, art history, and critical theory possible and necessary. In this manner we hope to contribute to the expanding map not only of the borderlands of modernism, but also of those newly opened territories now identified with postmodernism.

Saul Ostrow

FOREWORD
AESTHETIC VISIONS
AND RE-VISIONS

That I would be writing a foreword to a book containing the autobiographical sketches of John Ruskin, Walter Pater and Adrian Stokes, much less soliciting such a book for publication, came as a surprise to me because those of my generation (educated in the 1960s) were taught to avoid developing a refined taste and being concerned with aesthetics. Aestheticism was equated with elegance, taste and beauty, everything that we were being taught *not* to aspire to. These effects had earned bad names for themselves, and had become too easy to affect. Beyond this, aestheticism represented the very things that the "middle brows" had learned to expect from art, and we were too sophisticated and too ambitious for such limited objectives.

The world of the Vietnam era viewed itself as being defined by radical cultural and technological changes. Within the fields of art's production and the realm of criticism that we thought was "relevant," the experience and appreciation of truth and beauty were negligible. Such "experiences" were something of the past, and to speak in such terms was to expose one's self as a romantic—a dabbler in metaphysics and subjectivity. The materialist "reality" of the postwar era had expanded the media, subject and goals of the arts beyond the search for "truth and beauty"—art for my generation was premised on an antiaesthetic stance. With the abandonment of aesthetic goals, the aesthete—who we were taught wallowed in sensuous pleasure and was prosaically rapt by arcane values—had become anachronistic. Such practices were for dandies and dilettantes whose values were devoid of relevancy to anyone except their most selfish (and narcissistic) selves.

Those of us intent on becoming hard-nosed avant-gardists mocked those artists who actually upheld Matisse's view that a good painting was like a good armchair—something comforting. Clement Greenberg's appeal for an art that was purely visual was also rejected: what could the significance be of an art that was merely optical? As for nature, it was an artifice: urban reality had replaced it; *ideas* were what mattered. The senses, if they were to be addressed at all, were to be assaulted. Though we upheld the slogans of "art for art's sake" and the "merging of art into life," neither were thought of in the nineteenth-century aesthetic terms and practices in which they had originated. We were, after all, engaged in a youthful, Dionysian rebellion intent on redressing social inequities as well as promoting the postindustrial cultural values associated with "sex, drugs and rock and roll." On the other side, the significant changes brought about by electronic media and new technologies were beginning to make their effects felt—both consciously and unconsciously. We became aware of these new media's abilities to supply us with mundane experience while at the same time producing a delirium, bombarding us with sensory effects that both manipulated our sense of time and space and reordered our expectations.

"Everyday life" seemed to be increasingly defined by the expanding field of entertainment, and commercial distractions. Through group testing, our susceptibility to colors, sounds, shapes and scents was being used to delineate the parameters of our desires and tastes, so that they could be packaged and sold back to us. Infinitely replicable images and objects tailored to appeal to us filled the world, intent on improving our experience of the everyday. The quality of these was differentiated only by the processes and materials used in their production. The world was being aestheticized while we became anaesthetized. Identity, taste and style changed with a planned regularity. Art existed in what André Malraux had dubbed the "museum without walls." Painting, sculpture, architecture—even nature—had come to be known only as images; vision was becoming a sense disassociated from bodily experience and tactile objects. Increasingly, the complex network of our senses and emotions was being fragmented, each sense or emotion relegated to its own individuated territory.

Out of this situation arose two seemingly antithetical projects capable of resisting this loss of the complexity of experience. One was

the hedonistic embrace of the hallucinations produced by mass culture, the other the "high road" to a self-consciousness whose content was an awareness of how social, economic, political and cultural structures organized our relationship to the "here and now" of the material world. What this meant for artists and their audiences was that aesthetic reflection was to be bypassed so the intensity of everyday life could be felt. The distanced self-reflection induced by a connoisseurship that relied on and maintained traditional ideas of skill, harmony and transcendent values obviously had no place in such a world. Such qualities were of no consequence to artists who were intent on reflecting material reality. The idea that art and life could deliver a moment of self-reflection and fulfillment was to be swept away and replaced by an awareness of philosophical or social principles. Ideas, information, images of images, events, situations, processes and their temporality were to be both means and subject. In this scenario the "beholder" is not conceived of as an evaluator, but as a passive member of an audience that needs to be informed and whose values are to be challenged. In such a context, what could Baudelaire, Ruskin, Fry, Pater, Proust and Stokes, with their refined sensibility and aestheticism, have to teach us?

For all the changes being wrought in the 1960s, modernism and its mechanisms still held sway. The rejection of aestheticism was perceived as just another step in art's movement toward self-definition and autonomy. The art object in our postindustrial society was no longer an object of contemplation, but was reconceived as a text that led only to the conditions of its own being and to other texts. Writers as different as Marshall McLuhan, Roland Barthes, Susan Sontag and Herbert Marcuse raised questions about the beholder's ("reader's") role and response to such texts. With this paradigmatic shift, art was conceived as interactive and its audience collaborative. Interpretation, and the resistance to it, became reciprocal positions. It was proposed that one could respond to the text's (art's) form, or content, or the interrelationship between the two, in order to divine what it actually signified. It was the experience of this process as well as the information brought to that experience by the viewer that constituted the whole art "experience" and its content. Physical, psychological and subjective experience again took their places alongside the conceptual. If the practice of art existed only as a cultural institution within

its history, its reception resided within the limitations of language's ability to represent and inform the viewers of their own responses.

The inability to objectify modernism's criteria and standards has resulted in the return to subjectivity as well as other issues long thought resolved. These have reemerged—from the margins— significantly changed. The new methodologies of poststructuralism have delivered up other possible understandings and relationships. The aesthetes and their lives are now texts that can be opened to reveal the multiplicity of texts that lie beyond the definition of taste they were once thought to represent. Within the autobiographical texts of John Ruskin, Walter Pater and Adrian Stokes assembled in this volume, David Carrier's reading reveals them to be less about art appreciation or an aesthetic approach to everyday life than they are about the point where such stances interface with issues of identity, politics and desire.

Through a comparison of the differences and similarities of these three men's times, lives, responses and understanding, Carrier points out that Ruskin's, Pater's and Stokes's views have surreptitiously worked their way into our outlooks and thoughts. In part, this book is an acknowledgment that aesthetics—and the lives of those dedicated to its pursuit—is no longer some high-brow curiosity or the idle pursuit of the rich, but a theme now circumscribed and inscribed by the multiple disciplines of sociology, psychoanalytic theory and philosophy. Given that the technologies of reproduction and the nature of art and museums have changed so much, obviously Ruskin's, Pater's and Stokes's visions can no longer function as models for the experience of art and life. Yet as David Carrier points out, they can perhaps suggest how to understand our own lived situation, as we once again try to make sense of our experiences and selves.

Saul Ostrow

ACKNOWLEDGMENTS

*T*thank Saul Ostrow for inviting this project and two very patient friends, Paul Barolsky and Marianne L. Novy, for criticizing my introduction.

In our correspondence and his publications, Paul Tucker has given valuable suggestions about how to read Pater. I learned a great deal about Pater at the conference organized by Stephen Bann in Canterbury, in 1994, and from my interview of Louis Auchincloss in the fall of 1996.

Twenty some years ago, Richard Wollheim introduced me to the writing of Adrian Stokes; my present account is indebted to the many people who have discussed Stokes with me—most especially to Ann Stokes Angus and Ian Angus, who have supported my work generously over the years. The dedication is given to three friends who share my fascination with Stokes.

Like everything I write, this book owes much to Arthur C. Danto.

The full literature on Ruskin and Pater is enormous. My bibliography, which in part overlaps with the materials footnoted in the introduction, includes only those sources I have found of most use.

INTRODUCTION

England and Its Aesthetes
by David Carrier

INTRODUCTION: ENGLAND AND ITS AESTHETES

They argued about the relative merits of Ruskin and Pater . . . Ainslie quoted a remark made to him by Pater in person: 'I can't believe Ruskin could see more in St. Mark's at Venice than I do!'; to which Proust retorted, with a despairing shrug of the shoulders: 'What's the use! You and I will never see eye to eye about English literature!'

George Painter, Proust: The Early Years

*O*n very fashionable views of contemporary art, we have reached the end of the era of aesthetic art—the painting and sculpture traditions loved by John Ruskin, Walter Pater and Adrian Stokes are to be replaced by antiaesthetic art. Andy Warhol, the most influential recent American artist of our era, hardly inspires aesthetic contemplation. If the writing of admirers of the tradition of aesthetes is to be of more than historical interest, it must deal constructively with the fact that this way of thinking has become beleaguered. The most philosophically challenging response to Warhol is that of Arthur C. Danto. His view that ours is a posthistorical era both allows that traditional "aesthetic" art can and will continue to be made, and claims that Warhol's work defines the end of art history as the story of progress. Danto's highly original analysis of Warhol's sculpture *Brillo Box* both negates and preserves the traditional conception of the aesthetic. (Danto's basic conception is Hegelian, so it is appropriate that the German verb *aufheben* is needed to describe this simultaneous negation and preservation of "the aesthetic." By distinguishing *Brillo Box* from the physically identical object in a 1960s grocery store, Danto preserves in a highly attenuated form the traditional aesthete's doubling of the world, replacing Baudelaire's conception of the "surnatural" with this distinction between *Brillo Box* (the art-work) and a mere Brillo Box.[1]

Danto's essays on Warhol are justly famous—what in the present context deserves note is his little-known discussion of a very different figure, his friend the Japanese woodcut printer Shiko Munakata:

['t]here were for Munakata no *views*, no scenes . . . everything was paintable . . . whatever was there, before the eye, was equally worthy of being put into paint with everything else: a patch of light on a bench, a telephone pole, a cellar door, a garbage can, a scrap of paper—or my daughter Lizzie's red hair—were as suitable to artistic transformation as alps or flowers; just as such, because they were there, it being no business of his to discriminate.[2]

Munakata certainly was an aesthete, as is Danto himself. A fully up-to-date account of the tradition of Ruskin, Pater and Stokes would need to relate their ways of thinking to Danto's subtle analysis of Warhol's and Munakata's art. Such an analysis would require extending the concerns of these three artwriters into the present, explaining in what ways the development of computer-based image processes modifies the traditional concepts of the aesthetic, canceling and preserving that intuitive focus on immediate presentness.

No one is born an aesthete, and few parents train their children to be aesthetes. How then, in mostly philistine cultures, do some people find this way of life centered around visual pleasure the source of their values? One reason this question is worth answering is that such odd people have had an influence out of all proportions to their numbers—without them, neither academic art history nor the modern museum would exist; another, that a genealogy of the aesthetic teaches us much about both art and culture. English aesthetes have been especially influential. "It is no accident," Kenneth Clark remarks in his introduction to John Ruskin's *Praeterita*,

that the three or four Englishmen whose appreciation of art has been strong enough and perceptive enough to penetrate the normal callosity of their countrymen—Hazlitt, Ruskin, Roger Fry—have come from philistine, puritanical homes.[3]

If you are brought up surrounded by art, he adds, then you take it for granted and end up either impervious to it, "or faddy and perverse, like museum officials." An aesthete never takes art for granted—for

him it is a necessity, and so what seems perverse is that most people fail to recognize its importance.

The autobiographies of the three greatest English aesthetes—John Ruskin, Walter Pater, Adrian Stokes—men whose appreciation of art has, in the end, remained strong enough and perceptive enough to affect generations of readers, reveal much about art. Other aesthetes have produced autobiographies, but my figures are these great writers in a distinctively English tradition. To paraphrase F. R. Leavis on the English novel, what makes these *the* great figures is that "they are significant in terms of the human awareness they promote; awareness of the possibilities of life."[4] Whether or not Pater's "The Child in the House" is autobiographical, a notion asserted by older commentators but which been convincingly denied recently, the essential way of thinking presented is his; the central theme, after all, is how someone recognizably akin to Pater becomes an aesthete.[5]

This is a very rich tradition, for each writer comments on his precursors.[6] Reading Pater as he responds to Ruskin, one notices that his very lack of assertiveness, which taken in isolation might seem a weakness, appears instead a strength; Adrian Stokes, commenting upon both Ruskin and Pater, rethinks the claims of the earlier writers. We get a multiplicity of perspectives, each account becoming richer individually when set thus in context. Here introducing three additional aesthetes is essential: Baudelaire, one of Pater's essential sources; Proust, Ruskin's great, ultimately critical admirer, who offered a strong reading of that writer's assimilation of aesthetic to religious values; and Roger Fry, who rejected Ruskin's link of aesthetic and religious values, and was himself in turn a writer Stokes both reacted against and learned from. To properly understand this great English tradition, we need to grasp the relationship of Ruskin, Pater and Stokes to these other aesthetes who did not produce autobiographies.

What exactly then is an aesthete? Ruskin, Pater, and Stokes give interestingly different definitions, but all of them would agree with Clement Greenberg:

> I think a poor life is lived by any one who doesn't regularly take time out
> to stand and gaze, or sit and listen, or touch, or smell, or brood, without
> any further end in mind, simply for the satisfaction gotten from that
> which is gazed at, listened to, touched, smelled, or brooded upon.[7]

When he adds that modern everyday life "is not conducive to this kind of thing . . . ," he indicates why aesthetes, even if they are formalists, tend to be social thinkers. Of course, art lovers are often snobs, but anyone who greatly values aesthetic experience is likely to ask why, as yet, only an elite is able to enjoy such pleasures. There are many poor aesthetes, and almost all well-off people are of course not aesthetes; but there is a natural connection between being an aesthete and reasonable prosperity. A philistine finds obsession with art incomprehensible; an aesthete, conversely, knows that those who lack the leisure to appreciate art as he does really are missing something. In defining an aesthete as someone who gives a central place to the pleasures of visual experience, valued both for its own sake and as a source of self-knowledge, I distinguish aesthetes from art historians and others for whom interpreting and presenting artworks is a profession or a business. Being an aesthete is a way of life.

When aesthetic experience is characterized in more detail, then we get to the interesting disputes. Roger Fry claims that "in all cases our reaction to works of art is a reaction to a relation and not to sensations or objects or persons or events."[8] Ruskin, Pater and Stokes would disagree. Greenberg and Fry were both heavily influenced by the Kantian tradition in which

> the aesthetic judgment . . . affords absolutely no . . . knowledge of the object. . . . the judgment is called aesthetic for the very reason that its determining ground cannot be a concept, but is rather the feeling . . . of the concert in the play of the mental powers . . .[9]

In her description of a formalist lecturer, Muriel Spark nicely shows how easy this way of thinking is to parody:

> Mr. Lloyd . . . said nothing of what the pictures represented, only followed each curve and line as the artist had left it off. . . . The ladies of the *Primavera* . . . provided Mr. Lloyd with much pointer work. He kept on passing the pointer along the lines of their bottoms which showed through the drapery. The third time he did this a collective quiver of mirth ran along the front row of girls. . . .[11]

This extreme tendency to separate art from life appears also among nonformalists. "My life," the very distinguished twentieth-century English aesthete and curator John Pope-Hennessy explains,

has been devoted to studying works of art and putting them to use. To the material well-being of the world neither activity is of much consequence; it does not make the poor less poor, it does not sustain the hungry, it does not diminish suffering or redress injustice.[11]

In perhaps provocatively echoing Pater's wayward reader Oscar Wilde, Pope-Hennessy is hardly offering a view a museum would dare present nowadays when seeking public funding. In their individual ways, Ruskin, Pater, and Stokes challenge both the formalist tradition and any such tendency to separate "art" from "life." Unlike an art historian, an aesthete may focus on nature, or on the urban environment.[12] Ruskin, Pater, and Stokes, noted art critics, are not primarily concerned—in the writings collected here—with artworks; they are concerned with perception as a way of knowing, and with self-knowledge gained from aesthetic experience. Art for them comes afterward.

An aesthete is someone deeply engaged with painting and sculpture who sees the world in terms usually associated with viewing art, giving special value to the visual world for its own sake; and who brings this way of thinking to experience outside of art. Aesthetes divide their world, making a distinction between everyday practical ways of seeing and those privileged moments associated with aesthetic experience. Most people do not, and so this division seems less to reveal how the world is than to constitute a relatively unusual way in which things may be seen. Aesthetes come to divide the world thus through travel—in their autobiographies Ruskin and Stokes are much concerned with going from unaesthetic England to the Swiss Alps and the visual pleasures of Italy. (The ultimate such autobiography of the aesthete as traveler is *Pale Fire*—Charles Kinbote travels between the "real" world of terra and the imagined world of his childhood land Zembla.) And through dreams, which also take us out of our everyday life—Pater's 'autobiography' is build around the recounting of a dream.

An artist, Baudelaire writes, "is only an artist on the condition that he is a double man . . ."[13] His account of the "correspondences" offers a highly instructive account of this division of the world. Nothing could be duller than bourgeois life, as he experiences it; but when he turns to art his tediously sardonic misanthropy is replaced by a positively exhilarating, often even manic, pleasure in looking.

"To glorify the cult of pictures (my great, my unique, my primitive passion)"—that, he rightly recognized, was his gift.[14] Only when he was an aesthete did life become interesting. Baudelaire radically separates those special highs in which the world is seen aesthetically, and attention can productively be focused on visual artworks, and everyday experience of what by contrast may be disparagingly called "reality."

The division which Fry makes in separating off practical concerns from aesthetic reality arises for Baudelaire because painting, like drugs and poetry, are associated with the "surnatural," the everyday world as it appears when transfigured. What was unified—the expanse of possible experience—thus becomes divided, and the autobiography of an aesthete shows how this division has come about. Ruskin, Pater, and Stokes say so much about their childhoods in part because, as Baudelaire noted, the naïveté of a true aesthete is akin to a return to childhood. Aesthetes are much concerned with transitions, which thus divide their worlds: Ruskin with that magic moment when he went with his parents to Schaffhausen; Pater with Florian's dream of childhood; Stokes with contrasting the miseries of his childhood in London parks and his discovery of the radical clarity of light in Italy. They became aesthetes in key transitional moments: for Ruskin, in viewing the Alps and, in Turin, Veronese's painting; in Pater's text, learning the inseparable link of sensitivity to form, and the distaste for needless suffering; in Stokes' *Inside Out*, discovering the unmenacing openness found in Italian living and Cézanne's painting.

What ultimately is at stake in the aesthete's dualistic way of thinking, Stokes suggests in such late texts as *Three Essays on The Painting of our Time* (1961), is less the particular way in which such divisions are created than the simple fact that they be created within what otherwise would be a homogeneous field of experience. His use of Melanie Klein's psychoanalytic contrast between the regressive state of oneness with the mother and the adult demand for self-sufficiency identifies in abstract terms an oppositional way of thinking developed in very concrete ways in *Inside Out*. This autobiographical essay (reprinted in this volume), explains why he found Klein's contrast so fruitful.

For Ruskin, looking at Swiss landscapes is a natural result of studying Turner's images of those scenes. His travels south with his parents revealed the dramatic contrast between the barren neighbor-

hood Protestant chapel in suburban London and the Rouen cathedral. (Stokes, too, writes his autobiography in terms of travel, and he also has a near contemporary artist as hero—his is Cézanne.) The change produced by this travel is not so much a change in Ruskin himself— whose personality is formed early on—as it is a change in the objects of his study; in maturity he finds new ways of using the skills developed in his solitary youth when he read the Bible or the works of Sir Walter Scott and watched his parents' garden grow. (Stokes developed more dramatically—from what we learn of his childhood from *Inside Out*, it is remarkable that he became a great scholar of *quattrocento* sculpture.) Is it remarkable that Ruskin, a child much occupied with counting the floor tiles and looking at a carpet became a great observer of decoration in Venice?; or surprising that a boy so much attached to his family garden wrote so passionately about landscape painting?

Gardens have a place also in the accounts of Britain's other aesthetes: "My first passion," Fry writes,

> was for a bushy plant of large red oriental poppies . . . the poppies were always better than my wildest dreams. Their red was always redder than any thing I could imagine when I looked away from them . . . the poppy plant was the object of a much more sincere worship than I was at all able to give to 'gentle Jesus' and I almost think of a greater affection than I felt for anyone except my father.

Going on to describe his mother's ridicule of his passion and his own subsequent disillusionment explains why Fry rebelled against his family's values. Ruskin's trouble, by contrast, was that for all of his published criticism of his parents, he remained almost always as obedient as when a child. That is why neither the first sight of the Alps nor his turning against his religious tradition in Turin with which I end my selection of *Praeterita* mark real personal development; Ruskin, like some other precociously talented people, remains the same: incapable of development, even while the objects of his affection change.[16] His account of Schaffhausen deserves comparison with the comparable recognition scene from the life of the fictional figure Humbert Humbert, whose erotic fixations are similar to his: "I find it most difficult to express with adequate force that flash, that shiver, that impact of passionate recognition."[17] For Nabokov's protagonist this recognition scene is a return to an earlier, already

experienced moment; like Ruskin, he cannot learn from experience because his personality is already essentially complete.

Anthologizers tend to apologize for making cuts in Ruskin's text, a procedure quite unnecessary when the full thirty-nine volume Edwardian edition of E. T. Cook and Alexander Wedderburn is relatively accessible. You learn a lot about Ruskin, I have found, by doing excepts, forcing yourself to ask which—for your purposes—are his most important passages. Any selection is an interpretation: mine focuses on Ruskin the art lover; an account of his social criticism would concentrate on different materials. One effect of any such drastic editing is to make Ruskin more like Stokes; my excerpted *Praeterita* appears as a more elliptical, less fully worked-out narrative than the (fuller) original.

Pater "mentioned Ruskin just once in his letters . . . Ruskin is ignored, by name, in the books and essays, yet he hovers everywhere in them."[18] Ruskin is so involved in a religious worldview that, for my purposes, he is something of a transitional figure; passionately involved with visual experience, he interprets art (and nature) in implicitly or explicitly religious terms. A true aesthete cannot easily also be so deeply religious. For Ruskin, Turner's greatness exists in his capacity to mirror the complexity of creation; viewing Amiens cathedral, like studying the Alps, reveals God. Since almost all of the art most interesting to him was Catholic, it is not surprising that his parents worried that he might be tempted by Catholicism. But for all of his religious doubts, he remained Protestant—a fact that certainly influenced his politics heavily. What makes Ruskin a premodernist is not simply his fascination with medieval art—whose rediscovery was one important achievement of nineteenth-century art history—but also his tendency to assimilate aesthetic and religious values.

No doubt the roots of the aesthete's ways of thinking are religious, his division of the world a secularized version of the traditional Christian distinction between earthly and heavenly realms. Insofar as art history tends to secularize old master sacred art, leaving aside concern with its Christian content, nowadays Ruskin's ways of thinking inevitably seem antiquated. His true heirs are those moralizing Marxists who know that, whatever the artist's apparent intentions, art must express political concerns. Warhol's "great billboard images of the Coca-Cola bottle or the Campbell's soup can

... *ought* to be powerful and critical political statements."[19] (Why?, one wants to ask.)

Ruskin's political theorizing, not grounded in any real analysis of the society of his own day, has less to do with Karl Marx's theorizing than with the delightful fantasies of those pre-Marxist Utopian Socialists, much admired by Marx, who planned a perfect society. When Ruskin lays down the rules of the Company of St. George, specifying the weight and stamp of the currency, describing the dress and jewels of the people, and indicating what books will be in the library, how can we not be reminded of Charles Fourier's phalanxes?[20] And yet, when near the end of *Unto This Last* he writes,

> There is no wealth but Life. . . . That country is the richest which nourishes the greatest number of noble and happy human beings; that man is richest who, having perfected the functions of his own life to the utmost, has also the widest helpful influence . . . over the lives of others[21]

he surely is correct, is he not? John Ruskin was that rare creature, an art lover who reflected seriously on the moral dilemmas inherent in his situation, a rich man who didn't just talk about politics, but acted.

One decisive difference, of great political importance, between Ruskin and Pater comes in the ways they view suffering. It is hard to resist admiring the man who, when he was about to lecture at Oxford,

> was hindered for a moment by a nice little girl, whipping a top on the pavement . . . she had on a large and dilapidated pair of woman's shoes. . . .
>
> There were some worthy people at my lecture. . . . But all the time I was speaking, I knew that nothing spoken about art . . . could be of the least use to anybody there. For their primary business, and mine, was with art in Oxford, now . . . and art in Oxford now was absolutely dependent on our power of solving the question—which I knew that my audience would not even allow to be proposed for solution—"Why have our little girls large shoes?"[22]

(Here, nicely sublimated, we find his erotic obsessions.) Insofar as the motivating power for personal change is love, Ruskin's inability to develop is shown by his failure to learn to love. Ruskin the aesthete became a social critic when he became aware of how rarely privileged his life had been. And then, concern with social reform tended to displace aesthetic concerns; for Ruskin, political and artistic values tended to be mutually exclusive.

For Pater, pity is built into the nature of the aesthetic experience itself, which links sensitivity to form with what–in the text reprinted in this book—he calls "an almost diseased sensibility to the spectacle of suffering." *Marius the Epicurean* extends sympathy also to the horse taken to slaughter:

> [a]lthough morning air was still so animating, and pleasant to snuff. . . . I had come across the incident just when it would figure to me as the very symbol of our poor humanity . . . and those imperfect sympathies, which can never quite identify us with one another. . . .[23]

Ruskin came to understand intellectually that his society was unjust; Pater, directly linking aesthetic sensitivity to distaste for needless suffering, sees in an immediate way that needless suffering is wrong. This is why quoting the famous "Conclusion" of *The Renaissance* ("Art comes to you proposing frankly to give nothing but the highest quality to your moments as they pass, and simply for those moments' sake") out of context is highly misleading.[24] Pater isn't an irresponsible aesthete: to properly attend to that passing moment requires that one respond morally to what is seen. In his kindly intended yet bullying way, Ruskin wants to do for the poor what he knows is best for them; Pater, a gentler person, desires that they have the chance to become aesthetes.

Ruskin recalls the lack of parental love; Florian, the unhappy consequences of picking some flowers. The aesthete, they imply— and this is also a central Stokesian theme—must perform an act of reparation, mending his damaged psychic world. And yet, this contrast of the two aesthetes is not entirely fair—it does not adequately identify the problems with Pater's account. When Florian, entering the usually closed garden, picks the flowers and then when they die feels "an inexplicable excitement . . . which disturbed him," there is something both excessive and undermotivated in his response. The very sheltered young Buddha—a child shocked by the discovery that people die—knew that flowers do not live after they are cut. Pater's elusiveness, and subtlety, consists in part in the ambiguity of his presentation of Florian. Is the child meant to be neurotically sensitive, or is his response reasonable? Perhaps Pater was influenced by Baudelaire's suggestion that intense aesthetic pleasure easily becomes painful; the men share a fascination with sadomasochism.

Unlike young Ruskin, Pater's Florian was not taken on the grand tour by nouveau riche parents; he discovers the aesthetic for himself in his quite ordinary garden. (Having a garden, he is relatively privileged.) In that way, he—more so than young Ruskin—is someone a modern reader can easily identify with. Under the spell of Pater, I view on a late fall, the telephone pole outside my kitchen, which is exquisitely beautiful for a brief period just before sundown. Unlike Florian, I am not made anxious by this experience of beautiful transience—I know that the sun will soon rise again. But had I never read Pater, I probably would have failed to properly attend to this moment.

One large difference between Ruskin and Pater comes in how they view Christianity: Ruskin sees the visual world as manifesting God's glory; Pater finds moral progress in a Christian sense of mercy. They focus on different, though perhaps not incompatible, religious concerns. The modern reader, hopefully sensitive to the ways in which Pater represses his homosexual side, is less likely to attend to the manner in which the novelist-philosopher responds to Christianity; and yet, unless the critical target of *Marius the Epicurean* is understood to be Victorian England as seen from a Christian perspective, the book, and Pater's aesthetic, are impossible to understand.[25] Pater accepts Christian values but he is quite certain that all of the teaching of Christianity cannot literally be true. And so his unavoidable compromise, responding to Christianity merely aesthetically, led him to make an unhappy, obviously morbid, association between aesthetic pleasure and death.

Ruskin is overwhelmed by his first sight of the Alps, but viewing them doesn't change him. The most powerful recognition scenes in his autobiography come not in looking at nature, for which he is well prepared by his prior knowledge of art, but in his shocked discovery of the power of erotic love: "I was thrown, bound hand and foot, in my unaccomplished simplicity, into the fiery furnace, or fiery cross, of these four girls[—]who of course reduced me to a mere heap of white ashes in four days." Nothing in his reading had prepared him for meeting them. And yet, though he is very shocked, he is not really changed—for all of his life he responds to other very young women in exactly the same way. Pater's Florian, by contrast, really does change, when, after picking flowers and observing their decay, "for

the first time, he seemed to experience a passionateness in his relation to fair outward objects. . ."

The most important change in Ruskin comes at the very end of *Praeterita*, when the account of the remembered fireflies marks the end of his career as writer. He changes because he is going mad. (I have not included that passage both because it is, for my purposes, anticlimactic and because a brilliant commentary by William Arrowsmith has persuaded me that it is too intertextual to be understood properly in isolation.[26]) This judgment that Ruskin failed to develop may seem unfair: although he did not, as his parents desired, become a bishop or the Christian Byron, when he wrote his great pioneering social history of Venice, and his massive account of Turner and the history of landscape painting, he certainly acquired new skills. The real question for the reader of an autobiography is whether its subject presents himself as changing; and certainly the iterative mood of *Praeterita*, the tendency to focus on repeated or habitual actions, tends to undercut any sense of personal development.[27] The book, though an autobiography *by* an aesthete, is not an autobiography *of* an aesthete, for it doesn't explain how Ruskin became an aesthete.

Perhaps only the comparison of Ruskin to Stokes makes us so aware of this distinction. Stokes changes dramatically when, on his first arrival in Turin, he sees an entirely open space with Italians dining, the sight for which his schoolboy declining of the Latin word *mensa* (table) readied him: "I was prepared for Italy: I had been preparing from an early time." Part of the difficulty of *Inside Out* comes in understanding how, exactly, Latin grammar prepared Stokes to see modern Italy; the virtuosity of his narrative comes in motivating what initially seems a highly shocking jump-cut transition. Stokes, in this respect the extreme opposite of Ruskin, focuses on transitions: in part one, the movement from London parks to Italy; in part two, the jump from the train trips of Stoke's youth to the journeys of Cézanne. Both parts bring together two seemingly different topics: Stokes' liberating sense of the openness of Mediterranean life, and Cezanne's paintings. The journey is "from the hidden to the open"; to become an aesthete, he implies, you must learn to make this movement from inside to outside. Unlike Ruskin, Stokes has little to say about his parents, either in childhood, when

he is mostly concerned with the London park, or when later he travels to Italy alone. Like the Cézanne he describes, Stokes aspires to a certain impersonality.

Just as Ruskin comes to the Alps prepared by Turner's pictures, so Stokes arrives in Italy knowing Latin. No doubt this transition in part one from London to Genoa can seem slightly illogical, as can the equivalent movement in part two from Stokes' childhood train trips to Cézanne's adult movements, back and forth, from the South of France to Paris. Cézanne's development, to follow the now clichéd account of Fry, provides a model for us all; moving from romantic to classical, his development has the same structure as Stoke's autobiography. Travel thus serves as an emblem describing personal growth. How eager Stokes was to assimilate very different things, and how surprising that he would appeal to Fry when his 1937 book *Colour and Form* had criticized Fry for treating color almost as a mere decoration"; now he calls Fry's *Cézanne* a "masterpiece."[28] While we may all aspire, like Stokes's (and Fry's) Cézanne, toward objectivity, how can an aesthete/writer imitate a painter when the virtues of this painter's work, absolute unconcealedness, are essentially pictorial?

To answer these questions, we need to understand how Stokes structures *Inside Out* like a travel book. When he was young, he went from London to Italy, and found himself. That journey, a transition of a very traditional sort—the experience of many young men on the "grand tour"—seems easy to understand: many present-day artists and art historians find their first experience of Italy liberating in similar ways. Interpreting this journey as a movement from the world of hidden menaces of Edwardian parks to the safe openness of Cézannesque Italy complicates the structure of Stokes's book. Stokes is telling his life story by redescribing the contrast, presented in his 1930s books about fourteenth-century Italian sculpture, between modeled works which reveal tension and that ideal carved art which is atemporal. This contrast between two sculptural traditions is also a story of development: Stokes is concerned both with literal spatial movement and with the psychic development, described by his psychoanalyst, Melanie Klein, in which one achieves maturity by engaging in reparation for the greedy, fantasized aggression of childhood. Going to Italy, he develops in ways Klein gave him the vocabulary to understand. That which is felt to

be menacing when subconscious becomes tolerable when thus acknowledged; Stokes comes to recognize that what he felt to be extreme dangers in fact were as much inside him as outside in the London parks. His highly personal account of the modern city as a challenging psychic environment provides a valuable supplement to the much discussed account of Walter Benjamin, another 1930s social thinker concerned with psychoanalysis.

When then the movement from London to Cézanne's Mediterranean world is repeated in part two of *Inside Out*, we move much more quickly to the "good state," which now is identified with the enduring values of Cézanne's art. Cézanne himself, a conventional hero for art lovers, is treated here in an unconventional way, his art valued not just aesthetically, but as a model for a psychically harmonious life. The aesthete's goal is less to become like Cézanne—his life was hardly ideally harmonious—than to achieve a life structured like one of his paintings. In what way, exactly, could such paintings provide models for the aesthete's life? One answer to this question is given by Stokes' title, *Inside Out*, which identifies the movement—from London to Italy, and from Stokes's early train journeys to Cézanne's late trips to Southern France—as also the taking outward of what originally was thought to be inside the self. Anxiety becomes manageable when it is possible to distinguish what is *genuinely* within from the dangers which merely appeared to be internal.

Travel, in both physical movement and emotional development, is continued four years later in Stokes's second autobiographical volume, *Smooth and Rough. Inside Out* ended with the model of Cézanne, *Smooth and Rough* begins not with Stokes's childhood, but with the birth of his first son, and the narrative closes with a very different concern, a psychoanalytic perspective on modern science and technology. Stokes's goal is to arrive at a changeless state, a place where menace has been left behind. He must thus develop to get outside the world of change, escaping menace by reaching a place in which nothing can be hidden. In both autobiographical books, his concern is less with a movement that can be completed, once and for all, than with a process, like Ruskin's continental travels, which must be undertaken repeatedly. (This concern with the aesthetics of process anticipates the theorizing of the American abstract expressionist painters whom Stokes came to admire greatly.) This narrative mimics the act

of reparation he learned about in his analysis with Melanie Klein, the literal journey but an outward indicator of this ongoing inner activity. Bringing *out* to the surface what was *inside* is a complex task.

Unlike Ruskin, Stokes was not religious, but when he notes that his was seven years of analysis, a number whose sacred associations—analyzed by Freud in *The Interpretation of Dreams*, which early on made a great impression on Stokes—are so obvious, he unavoidably draws attention to his unexpected affinities with Ruskin. It is hard even for a secular-minded person to avoid presenting personal development in quasi-religious terms; like many Christian heroes, Stokes moves from a fallen land to the place of salvation. Treating his own life as a quasi-religious pilgrimage came easily to Ruskin, who was so very well read in Scripture; and so there may seem some tension between reading *Praeterita* as a matter-of-fact telling of his life as it really was and its obvious Christian overtones. With Stokes, a secular-minded person, it takes a little more work to see that his whole narrative is both a literal, if very selective, accounting and—without any obtrusive interpretative intervention—symbolic. The balloons at the start of *Inside Out* were real balloons in an actual park, it would seem to be excessive to link their threatened bursting with Stokes's overpowering sense of anxiety were it not that he himself does just that. How can his autobiography *not* be understood to be intentionally a self-constructed myth—isn't that what he has in mind in self-consciously equating himself with Cézanne?

Stokes' story, told unpoetically, sounds simple: "When a child, I was taken to a park which I found frightening—then I went to Italy, and in the clear air felt happier." But stated so baldly, what story does not sound flat?: "I became an obsessive lover and wrote this book because, when long ago I was unable to sleep, I demanded a kiss from mama." Is Proust's fictional story more implausible? I am not hinting that an aesthete's autobiography cannot be true to the facts; I am merely pointing to fictive elements in Stokes's narrative. Insofar as the aesthete's goal is to explain why art matters to him, it is natural that he employ such literary devices. How better to explain pleasure in art's fictions than by presenting his life in terms which themselves are openly fictional?

In his beautifully condensed analysis of Ruskin's autobiographical account of "a visionary and also an aesthetic experience" (drawing

while recovering from a fever) Stokes describes Ruskin as "a tortured unappeased visionary, entranced by the utterly good, imprisoned without warning by an unutterable bad . . ."[29] Ruskin's aesthetic experience is more closely akin to the mystic's vision of oneness with God than to Cézanne's capacity to treat his landscape as a self-sufficient object, outside and entirely separate from him. There is no equivalent in Ruskin's writings to the miraculously self-critical *Smooth & Rough*, where Stokes comes to rethink his early fears of what was *hidden*. Ideally, Stokes says, the aesthete ought to be able to acknowledge the need for, and reality of, such separations. Stokes's aesthetic ideal differs from Ruskin's in ways which their autobiographies help us to understand. When for example, Ruskin notes that his religion unconversion occurred seeing a Veronese painting while hearing a military band outside the gallery, it is relevant to recall Stokes's claim that the essential values of the greatest visual art are unmusical. Ruskin's expressed desire to see without in return being seen explains in part the limits of his love life: so occupied with his own visual pleasure, he is oddly unconcerned with how the objects of his attention thought of him. The word "voyeur," used too broadly in recent art history writing to describe any male viewer attending to a painting, really does give some sense of how Ruskin conceived of looking.

Aided by psychoanalysis, Stokes had a capacity for personal growth not possessed by Ruskin or Pater. In making sculpture, carving stands to modeling as male to female, and so the superior values of carved art, which leaves nothing hidden, is understood in Stokes's early works in frankly gendered terms. The carver, *Quattro Cento* (1931) argues, creates an open space free of all menaces like those Stokes found in London parks. In the writings published after the two autobiographical volumes, he gives sustained attention to the modeling tradition, showing how his personal development dramatically transformed his aesthetic. Stokes's great strength is his capacity to reveal and use, in ultimately simple ways, his fantasy life. "My son, the inside-out," he wrote in *Smooth and Rough*, "is also an outside-in: he became identified with the house."[30] The fear he had in youth of the hidden places he feared in London parks—which later experience enabled him to see—was, for him, associated with the feminine. Feminist commentators will find Stokes's highly personal accounts

of pregnancy useful; his 1933 contrast of the sculpture of Barbara
Hepworth and Henry Moore, is it not remarkably prescient?

If "I speak dictatorially," Ruskin writes in *Stones of Venice*, that
only is because "I believe men of the longest experience . . . would
either think it so, or would be prevented from thinking it so only by
some morbid condition of their minds."[32] Ruskin believes that he is
always right, his opponents sorely mistaken. Taking to an extreme
the attitude of any forceful art critic, he writes as if no one but he
were seeing the objects of his attention—as if alternative perspectives
were inconceivable. Pater's famous claim, "the first step towards see-
ing one's object as it really is, is to know one's own impression as it
really is," would be incomprehensible to Ruskin, for whom his
impression shows things as they really are.[32] "Nietzsche is the Pater
of the German-speaking world": this sly characterization explains
why today Pater is more relevant than Ruskin.[33] Nietzsche's perspec-
tivism is closely akin to the attitude of Pater's aesthetic critic, who
asks of an artwork: "What effect does it really produce on me? . . .
How is my nature modified by its presence, and under its influence?"

My writing on art history and criticism has been frequently con-
cerned with a methodological problem: to the extent that such writ-
ing is personal, how can it achieve objectivity? In their frank
acknowledgement of the personal sources of their individual aes-
thetic ideals, Ruskin, Pater, and Stokes—more so than most art his-
torians—press this problem; insofar as they respond to paintings
and sculptures in highly individual ways, what can readers accus-
tomed to the more impersonal style of professionalized art history
make of their claims? "The first break in the ice," Pope-Hennessy
writes in acknowledging the importance of Stokes's writings, "was
due to a book called *Stones of Rimini* . . . it succeeded in communi-
cating through the printed page . . . the experience of physical tac-
tility that is central to an understanding of sculpture."[34] It has to
seem odd that the starting point for analysis of *quattrocento* carving
would be so highly personal. One difference between aesthetes and
historians of art is that the writing of Ruskin and Stokes extends in
natural ways the concerns of traditional travel literature. In Stokes's
Hampstead house, I found an old Baedeker, which described how in
Italy to arrange for changes of horses for your carriage. Young
Ruskin traveled thus with his parents. "Let no one imagine that

crossing the Alps is the work of a moment, or done by a single heroic effort," Hazlitt writes: "They are a sea of an entire kingdom of mountains."[35] Present-day art historians who fly over Switzerland to get to Italy are much less likely to write about their journeys than were these aesthetes.

Ruskin taught art history in ways which struck his contemporaries as highly odd; Pater, a professional philosopher, was an amateur art historian. By the time we get to Stokes, the distance between his ways of writing and those of his art historian correspondent, Ernst Gombrich, who was also interested in psychoanalysis, are enormous. Art historians teach their students how to contribute to a body of knowledge, while an aesthete has chosen a way of life; in this way, aesthetes are more like creative writers than scholars. An art historian aspires to contribute to the literature acknowledged in his or her footnotes; an aesthete, presenting a way of seeing, will likely find footnotes to be of little importance. Many major art historians are undistinguished stylists, for there is not necessary connection between interpretative originality and good writing; an important aesthete could not help but write highly distinctive prose. Art historians are professionals; aesthetes are involved in a way of life often associated with inherited incomes. Great aesthetes, characteristically narrow in their enthusiasms, could hardly be suitable teachers for an academic introductory survey course. From about 1845 on, Ruskin

> could endure no architecture later than that of the fifteenth century, no seventeenth-century artist save Velasquez, no Dutch or Flemish painting . . . He never looked beyond Europe, never felt the influence of China or Japan; for him French art ends with the Renaissance. . . . He knew nothing of Courbet or the French Impressionists.[36]

Similar observations could be made about the limited tastes of Baudelaire and Pater.

Stokes's greatest achievement was finding an uncompromising way of continuing the nineteenth-century tradition of Ruskin and Pater, demonstrating that an aesthete could accomplish something great in an era of professional art history writing. The danger for a writer so self-consciously indebted to two great precursors is in his belatedness; the title of Stokes's second major book, *Stones of Rimini* (1933), which echoes Ruskin's *Stones of Venice*, points to the problem.

Stokes's linking of carving values with stillness sublimates Pater's analysis, removing the aggression implicit in the close identification of ideal aesthetic states with death. When in his later writings Stokes turns to consider the artists of the modeling tradition he earlier dismissed or marginalized—Turner, Michelangelo, and Monet—he thus demonstrates his capacity to think through the implications of *Inside Out*; he has learned to enjoy art he once associated with regression.

John Ruskin's name does not appear in the Pléiade edition of Baudelaire's *Oeuvres complétes*; Charles Baudelaire's name is not in the index of the thirty-nine volumes of Ruskin's collected works. And yet they are near contemporaries, Ruskin forming his first secure estimate of Venetian and Florentine art just as Baudelaire was coming to know Delacroix. On August 14–17, 1844, his diaries show that Ruskin was making notes on Giovanni Bellini, Perugino, Guido, Titian, Tintoretto, and Veronese in the Louvre. Were he to have met Baudelaire there, what might they have said to each other? It is hard to imagine two great art writers less likely to appreciate each other's way of thinking, or tastes. Baudelaire cared nothing, so he said, for nature, and was totally uninterested in Ruskin's antiquarian interests; never travelling to Italy, he formed his view of art's history in the Louvre. City life, the source of Baudelaire's greatest criticism, was hardly Ruskin's concern; Baudelaire's satanism would have horrified Ruskin; although both men were sexually dysfunctional, they differed in ways that hardly could have made either one sympathetic to the other's problems.

Much can be learned, still, from comparing such very different aesthetes. "I used to confuse the smell of women with the smell of furs," Baudelaire recalls: "I loved my mother for her elegance. I was a precocious dandy."[37] Beyond mention, in a very early letter, of an adolescent visit to the art gallery at Versailles, he offers little explicit discussion of the childhood roots of his cult of the aesthetic, leaving to Sartre, some psychoanalysts, and other modern commentators the task of explaining how—in a generally philistine French culture, at a time when the greatest working artist, Delacroix, was old and without visible successors; when the tradition of modernism had not yet been inaugurated—he came to attach central value to painting. Compared with Ruskin, Baudelaire was a marginal figure; his ways of

thinking too personal to inspire the larger public, he was entirely incapable of being a political prophet.

Unlike our English aesthetes, Baudelaire was not much of a traveler. Apart from, in youth, his forced journey around Africa—a source for recurrent images of poetry but not an experience immediately relevant to visual art—and the unhappy voyage, near life's end, to "poor Belgium," he was essentially a Parisian. Baudelaire reinforced his dualistic way of thinking with drugs and with reactionary Satanism—in these ways, too, he differs from Ruskin, Pater and Stokes. Unlike them, Baudelaire was essentially an art critic, and that (together with his obsession with the modern city) has made him a figure of more immediate present-day day interest than these aesthetes who look back to Italy's Renaissance art.

Much recent art history, inspired by feminism and Marxism, tends to dismiss "the aesthetic" as fatally archaic and hopelessly compromised. What can survive of this seemingly old-fashioned pleasure in painting in an era of computer technology? One of the best-known American books of the 1980s was titled *The Anti-Aesthetic*, which says a great deal about such much-discussed ways of thinking:

> The uneasy nineteenth-century alliance of patrician and philistine, culture and society, is among other things the tale of an ideology in search of hegemony . . . As far as the Victorian bourgeoisie is concerned, the nostalgic neo-feudalism of a Carlyle or a Ruskin can be neither credited nor entirely disowned . . .[38]

"The aesthetic," this Oxford professor (Terry Eagleton) adds, can be understood as a way of deriving values when "neither civil society nor the political state would seem to provide . . . [them] with a particularly plausible foundation." It is a bit depressing, how little impact Ruskin's and Pater's books have had at Oxford, for this analysis is demonstrably unfair to Ruskin (and Pater), who did provide self-critical, well-reasoned argumentation about the origins of their ways of thinking. For Ruskin, "the history of painting is a political history . . ."[39] Focusing on the arguments of *Modern Painters*, which seem quaint, and on the literary style of *Stones of Venice* tends to draw undue attention to the differences between Ruskin and us postmodern art writers. What deserves more attention is Ruskin's role as a pioneering social-art historian. The German-language tradition of Hegel, Riegl,

Wölfflin, Warburg, and Panofsky—and I would add Gombrich to this list—"is not without relation to the writing of Ruskin, Pater and Fry. . . "[40] Stokes's psychoanalytic reworking of this tradition makes it easier to see ways in which art historians can learn from aesthetes.

"Art silently but ritually validates and invests with mystifying authority," so Carol Duncan has argued,[41]

> the ideals that sustain existing social relations. . . . Our very encounters with [art] in museums, galleries and art books are structured to create the illusion that the significance of art has little to do with the conflicts and problems that touch common experience . . . most of us believe that art, by definition, is always good . . . the purely esthetic is thought to be good . . .[41]

How different my experience is. When I see High Renaissance and Baroque Italian paintings at the Metropolitan Museum of Art, I feel immersed in conflict-filled worlds, struggles not so very different from those of the present-day in the streets of New York. When I walk over to the Islamic galleries, engaged by another culture's problems, this feeling is reinforced. No doubt there is authority implicit in the presence of these great collections from many different cultures in an American museum, but this authority, unlike religion, to which Duncan unconvincingly compares it, is not ultimately dependent upon mystification. The great artworks reward the prolonged attention I give them. I need not depend upon art history authorities to tell me that, I can see as much for myself.

How different Duncan's experience is from Ruskin's, Pater's and Stokes's. They critically question any straightforward equation of "the aesthetic" with "the good." In an odd way, the problems with Duncan's analysis arise because she, in this way like a formalist, focuses on art in the museum, without due consideration for the deeper roots of aesthetic experience.[42] (One of her targets is modernist formalism which tends, so she argues, to avoid dealing with the content of paintings. But her anti-Greenbergian approach is consistent, still, with isolating art in this way.) The confusions following from this starting point, shared by many of Duncan's colleagues, are instructive for a reader of Ruskin, Pater and Stokes. The museum, often by origin the house of a very rich man or king, contains well-guarded, very expensive artifacts. Christie's auction catalog do not discriminate artworks from jewels, antique cars and luxury houses.

Objects associated with aesthetic experience are thus inescapably
bound up with awareness of economic value, in ways which make
politically critical aesthetes uneasy. Art critics are especially aware of
this equation of aesthetic and economic value, for we can watch—as
if before our very eyes—a few paintings become much desired, and,
correspondingly, expensive. But we aesthetes also have broader,
more democratic concerns.

"At the very basis of Ruskin's work, at the root of his talent,"
Proust argues in the preface to his translation of Ruskin's *La Bible
d'Amiens,* is to be found what Ruskin himself identifies as "idolatry
. . . [that is] the serving with the best of our hearts and minds some
dear and sad fantasy which we have made for ourselves. . . ."[43] Were
Ruskin entirely sincere, he adds, "he would not have thought that
the crimes of the Venetians had been more inexcusable and more
severely published than those of other men because they possessed
a church in multicolored marble instead of a cathedral in lime-
stone. . . ." Ruskin's confusion of aesthetic and ethical values,
Proust argues, is both true to the nature of aesthetic experience—
"there is no beauty that is entirely deceitful, for aesthetic pleasure is
precisely what accompanies the discovery of a truth"—and a form of
self-deceit.

Proust's important discovery, one key to the reading of this tra-
dition, is that a Ruskinian fascination with aesthetic experience
remains trivial so long it is merely nostalgic, only looking backward
historically. To properly understand this English tradition we need
to look across the English Channel to understand Baudelaire's con-
ception of the beauty of modern life and how it was employed by
Pater in his revisionist account of Ruskin.[4] Baudelaire is the key fig-
ure, for he helped Proust understand how to find the beauty present
in everyday urban life. Marcel, the protagonist in Proust's
Remembrance of Things Past, has found himself unable to respond to
the beauty of the contemporary scene; the women "passed before me
in a desultory, haphazard, meaningless fashion, containing in them-
selves no beauty which my eyes might have tried, as in the old days,
to recreate."[45] The pleasure vanishing, all that remains, he adds, is "a
fetishistic attachment to the old things which it did once animate, as
if it was in them and not in ourselves that the divine spark resided
. . ." Only at the end of his novel has Proust come to understand how

to overcome this nostalgia. Then Marcel has become an aesthete. Notwithstanding the general praise Proust's novel attracts, nowadays Marcel's achievement is unlikely to be genuinely understood or emulated.

Ruskin, Pater, and Stokes are male, and two of the three had inherited incomes—but it is hard to generalize interestingly about aesthetes from this small group of relatively privileged people. The tendency of a significant number of recent art historians to write in openly personal ways—from their perspective as women, or gay men, or nonwhites—points to one unexpected way in which these traditional aesthetes' ways of thinking are reworked in our multicultural world.[46] Art historians, it would seem, are prepared again to acknowledge that evaluating and interpreting art is, unavoidably, in part a highly subjective activity. The autobiographies of Ruskin, Pater and Stokes must—if they are to be read profitably, responded to in unacademic terms. I believe that republishing these texts will encourage such reflection on the present uses of this grand and by no means exhausted tradition. Just as, for Proust, what is to be learnt from the account of his experience of involuntary memory is not that we should go as tourists to Illiers-Combray to replicate his experience, but rather that we must find our own equivalents to his madeleine, his uneven paving stones, his Vanteuil melody—our equivalents to these sources of involuntary memories. These three aesthetes are suggesting also that we, all of us, must identify for ourselves—within the framework of our own very different culture—something like their life experiences if we too are to become aesthetically sensitive. When he is drinking tea with his madeleine, Marcel realizes "that the truth I am seeking lies not in the cup but in myself."[47] Analogously, reading Ruskin, Pater and Stokes, we ought to treat their life stories not just as intellectual historians do, by analyzing the abstract ideas they present, but also as a means of finding ways (and here I echo Leavis) in which their writings can promote for us an awareness of the possibilities of life.

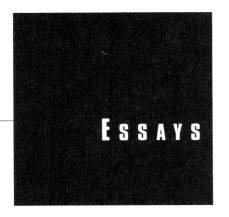

ESSAYS

by John Ruskin, Walter Pater
and Adrian Stokes

Selection from *Praeterita*
by John Ruskin

A Child in the House
by Walter Pater

Inside Out
by Adrian Stokes

SELECTION FROM PRAETERITA

John Ruskin

I am, and my father was before me, a violent Tory of the old school; (Walter Scott's school, that is to say, and Homer's,) I name these two out of the numberless great Tory writers, because they were my own two masters. I had Walter Scott's novels, and the Iliad, (Pope's translation,) for my only reading when I was a child, on week-days: on Sundays their effect was tempered by Robinson Crusoe and the Pilgrim's Progress; my mother having it deeply in her heart to make an evangelical clergyman of me. Fortunately, I had an aunt more evangelical than my mother; and my aunt gave me cold mutton for Sunday's dinner, which—as I much preferred it hot—greatly diminished the influence of the Pilgrim's Progress, and the end of the matter was, that I got all the noble imaginative teaching of Defoe and Bunyan, and yet—am not an evangelical clergyman.

I had, however, still better teaching than theirs, and that compulsorily, and every day of the week.

Walter Scott and Pope's Homer were reading of my own election, but my mother forced me, by steady daily toil, to learn long chapters of the Bible by heart; as well as to read it every syllable through, aloud, hard names and all, from Genesis to the Apocalypse, about once a year: and to that discipline—patient, accurate, and resolute—I owe, not only a knowledge of the book, which I find occasionally serviceable, but much of my general power of taking pains, and the best part of my taste in literature. From Walter Scott's novels I might easily, as I grew older, have fallen to other people's novels; and Pope might, perhaps, have led me to take Johnson's English, or Gibbon's, as types of language; but, once knowing the 32d of Deuteronomy, the 119th Psalm, the 15th of 1st Corinthians, the Sermon on the Mount, and most of the Apocalypse, every syllable by

heart, and having always a way of thinking with myself what words meant, it was not possible for me, even in the foolishest times of youth, to write entirely superficial or formal English; and the affectation of trying to write like Hooker and George Herbert was the most innocent I could have fallen into.

From my own chosen masters, then, Scott and Homer, I learned the Toryism which my best after-thought has only served to confirm.

My father began business as a wine-merchant, with no capital, and a considerable amount of debts bequeathed him by my grandfather. He accepted the bequest, and paid them all before he began to lay by anything for himself, for which his best friends called him a fool, and I, without expressing any opinion as to his wisdom, which I knew in such matters to be at least equal to mine, have written on the granite slab over his grave that he was "an entirely honest merchant." As days went on he was able to take a house in Hunter Street, Brunswick Square, No. 54, (the windows of it, fortunately for me, commanded a view of a marvellous iron post, out of which the water-carts were filled through beautiful little trap-doors, by pipes like boa-constrictors; and I was never weary of contemplating that mystery, and the delicious dripping consequent); and as years went on, and I came to be four or five years old, he could command a postchaise and pair for two months in the summer, by help of which, with my mother and me, he went the round of his country customers (who liked to see the principal of the house his own traveller); so that, at a jog-trot pace, and through the panoramic opening of the four windows of a post-chaise, made more panoramic still to me because my seat was a little bracket in front, (for we used to hire the chaise regularly for the two months out of Long Acre, and so could have it bracketed and pocketed as we liked,) I saw all the high-roads, and most of the cross ones, of England and Wales, and great part of lowland Scotland, as far as Perth, where every other year we spent the whole summer; and I used to read the Abbot at Kinross, and the Monastery in Glen Farg, which I confused with "Glendearg," and thought that the White Lady had as certainly lived by the streamlet in that glen of the Ochils, as the Queen of Scots in the island of Loch Leven.

My mother's general principles of first treatment were, to guard me with steady watchfulness from all avoidable pain or danger; and, for the rest, to let me amuse myself as I liked, provided I was neither fretful nor troublesome. But the law was, that I should find my own amusement. No toys of any kind were at first allowed;—and the pity of my Croydon aunt for my monastic poverty in this respect was boundless. On one of my birthdays, thinking to overcome my mother's resolution by splendor of temptation, she bought the most radiant Punch and Judy she could find in all the Soho bazaar—as big as a real Punch and Judy, all dressed in scarlet and gold, and that would dance, tied to the leg of a chair. I must have been greatly impressed, for I remember well the look of the two figures, as my aunt herself exhibited their virtues. My mother was obliged to accept them; but afterward quietly told me it was not right that I should have them; and I never saw them again.

Nor did I painfully wish, what I was never permitted for an instant to hope, or even imagine, the possession of such things as one saw in toy-shops. I had a bunch of keys to play with, as long as I was capable only of pleasure in what glittered and jingled; as I grew older, I had a cart, and a ball; and when I was five or six years old, two boxes of well-cut wooden bricks. With these modest, but, I still think, entirely sufficient possessions, and being always summarily whipped if I cried, did not do as I was bid, or tumbled on the stairs, I soon attained serene and secure methods of life and motion; and could pass my days contentedly in tracing the squares and comparing the colors of my carpet;—examining the knots in the wood of the floor, or counting the bricks in the opposite houses; with rapturous intervals of excitement during the filling of the water-cart, through its leathern pipe, from the dripping iron post at the pavement edge; or the still more admirable proceedings of the turncock, when he turned and turned till a fountain sprang up in the middle of the street. But the carpet, and what patterns I could find in bed-covers, dresses, or wall-papers to be examined, were my chief resources, and my attention to the particulars in these was soon so accurate, that when at three and a half I was taken to have my portrait painted by Mr. Northcote, I had not been ten minutes alone with him before I asked him why there were holes in his carpet. The portrait in question represents a very pretty child with yellow hair, dressed in a

white frock like a girl, with a broad light-blue sash and blue shoes to match; the feet of the child wholesomely large in proportion to its body; and the shoes still more wholesomely large in proportion to the feet.

While I never to this day pass a lattice-windowed cottage without wishing to be its cottager, I never yet saw the castle which I envied to its lord; and although in the course of these many worshipful pilgrimages I gathered curiously extensive knowledge, both of art and natural scenery, afterward infinitely useful, it is evident to me in retrospect that my own character and affections were little altered by them; and that the personal feeling and native instinct of me had been fastened, irrevocably, long before, to things modest, humble, and pure in peace, under the low red roofs of Croydon, and by the cress-set rivulets in which the sand danced and minnows darted above the Springs of Wandel.

The group, of which our house was the quarter, consisted of two precisely similar partner-couples of houses, gardens and all to match; still the two highest blocks of buildings seen from Norwood on the crest of the ridge; so that the house itself, three-storied, with garrets above, commanded, in those comparatively smokeless days, a very notable view from its garret windows, of the Norwood hills on one side, and the winter sunrise over them; and of the valley of the Thames on the other, with Windsor telescopically clear in the distance, and Harrow, conspicuous always in fine weather to open vision against the summer sunset. It had front and back garden in sufficient proportion to its size; the front, richly set with old evergreens, and well-grown lilac and laburnum; the back, seventy yards long by twenty wide, renowned over all the hill for its pears and apples, which had been chosen with extreme care by our predecessor, (shame on me to forget the name of a man to whom I owe so much!)—and possessing also a strong old mulberry tree, a tall white-heart cherry tree, a black Kentish one, and an almost unbroken hedge, all round, of alternate gooseberry and currant bush; decked, in due season, (for the ground was wholly beneficent,) with magical splendor of abun-

dant fruit: fresh green, soft amber, and rough-bristled crimson bending the spinous branches; clustered pearl and pendant ruby joyfully discoverable under the large leaves that looked like vine.

The differences of primal importance which I observed between the nature of this garden, and that of Eden, as I had imagined it, were, that, in this one, *all* the fruit was forbidden; and there were no companionable beasts: in other respects the little domain answered every purpose of Paradise to me; and the climate, in that cycle of our years, allowed me to pass most of my life in it. My mother never gave me more to learn than she knew I could easily get learnt, if I set myself honestly to work, by twelve o'clock. She never allowed anything to disturb me when my task was set; if it was not said rightly by twelve o'clock, I was kept in till I knew it, and in general, even when Latin Grammar came to supplement the Psalms, I was my own master for at least an hour before half-past one dinner, and for the rest of the afternoon.

My mother, herself finding her chief personal pleasure in her flowers, was often planting or pruning beside me, at least if I chose to stay beside *her*. I never thought of doing anything behind her back which I would not have done before her face; and her presence was therefore no restraint to me; but, also, no particular pleasure, for, from having always been left so much alone, I had generally my own little affairs to see after; and, on the whole, by the time I was seven years old, was already getting too independent, mentally, even of my father and mother; and, having nobody else to be dependent upon, began to lead a very small, perky, contented, conceited, Cock-Robinson-Crusoe sort of life, in the central point which it appeared to me, (as it must naturally appear to geometrical animals,) that I occupied in the universe.

My parents were—in a sort—visible powers of nature to me, no more loved than the sun and the moon: only I should have been annoyed and puzzled if either of them had gone out; (how much, now, when both are darkened!)—still less did I love God; not that I had any quarrel with Him, or fear of Him; but simply found what people told me was His service, disagreeable; and what people told me was His book, not entertaining. I had no companions to quarrel with, neither;

nobody to assist, and nobody to thank. Not a servant was ever allowed to do anything for me, but what it was their duty to do; and why should I have been grateful to the cook for cooking, or the gardener for gardening,—when the one dared not give me a baked potato without asking leave, and the other would not let my ants' nests alone, because they made the walks untidy? The evil consequence of all this was not, however, what might perhaps have been expected, that I grew up selfish or unaffectionate; but that, when affection did come, it came with violence utterly rampant and unmanageable, at least by me, who never before had anything to manage.

My judgment of right and wrong, and powers of independent action,* were left entirely undeveloped; because the bridle and blinkers were never taken off me. Children should have their times of being off duty, like soldiers; and when once the obedience, if required, is certain, the little creature should be very early put for periods of practice in complete command of itself; set on the bare-backed horse of its own will, and left to break it by its own strength. But the ceaseless authority exercised over my youth left me, when cast out at last into the world, unable for some time to do more than drift with its vortices.

My present verdict, therefore, on the general tenor of my education at that time, must be, that it was at once too formal and too luxurious; leaving my character, at the most important moment for its construction, cramped indeed, but not disciplined; and only by protection innocent, instead of by practice virtuous. My mother saw this herself, and but too clearly, in later years; and whenever I did anything wrong, stupid, or hard-hearted,—(and I have done many things that were all three,)—always said, "It is because you were too much indulged."

I was at Plymouth with my father and mother when my Scottish aunt died, and had been very happy with my nurse on the hill east of the town, looking out on the bay and breakwater; and came in to find

* *Action*, observe, I say here: in *thought* I was too independent, as I said above.

my father, for the first time I had ever seen him, in deep distress of sobbing tears.

I was very sorry that my aunt was dead, but, at that time (and a good deal since, also,) I lived mostly in the present, like an animal, and my principal sensation was,—What a pity it was to pass such an uncomfortable evening—and we at Plymouth!

But, before everything, at this time, came my pleasure in merely watching the sea. I was not allowed to row, far less to sail, nor to walk near the harbor alone; so that I learned nothing of shipping, or anything else worth learning, but spent four or five hours every day in simply staring and wondering at the sea,—an occupation which never failed me till I was forty. Whenever I could get to a beach it was enough for me to have the waves to look at, and hear, and pursue and fly from. I never took to natural history of shells, or shrimps, or weeds, or jellyfish. Pebbles?—yes if there were any; otherwise, merely stared all day long at the tumbling and creaming strength of the sea. Idiotically, it now appears to me, wasting all that priceless youth in mere dream and trance of admiration; it had a certain strain of Byronesque passion in it, which meant something: but it was a fearful loss of time.

The summer of 1832 must, I think, have been passed at home, for my next sketch-book contains only some efforts at tree-drawing in Dulwich, and a view of the bridge over the now bricked-up "Effra," by which the Norwood road then crossed it at the bottom of Herne Hill: the road itself, just at the place where, from the top of the bridge, one looked up and down the streamlet, bridged now into putridly damp shade by the railway, close to Herne Hill Station. This sketch was the first in which I was ever supposed to show any talent for drawing. But on my thirteenth (?) birthday, 8th February, 1832, my father's partner, Mr. Henry Telford, gave me Rogers' "Italy," and determined the main tenor of my life.

At that time I had never heard of Turner, except in the wall-remembered saying of Mr. Runciman's, that "the world had lately been much dazzled and led away by some splendid ideas thrown out by Turner." But I had no sooner cast eyes on the Rogers vignettes than I took them for my only masters, and set myself to imitate them as far as I possibly could by fine pen shading.

I have told this story so often that I begin to doubt its time. It is curiously tiresome that Mr. Telford did not himself write my name in the book, and my father, who writes in it, "The gift of Henry Telford, Esq.," still more curiously, for him, puts no date: if it was a year later, no matter; there is no doubt however that early in the spring of 1833 Prout published his sketches in Flanders and Germany. I well remember going with my father into the shop where subscribers entered their names, and being referred to the specimen print, the turreted window over the Moselle, at Coblentz. We got the book home to Herne Hill before the time of our usual annual tour; and as my mother watched my father's pleasure and mine in looking at the wonderful places, she said, why should not we go and see some of them in reality? My father hesitated a little, then with glittering eyes said— why not? And there were two or three weeks of entirely rapturous and amazed preparation. I recollect that very evening bringing down my big geography book, still most precious to me; (I take it down now, and for the first time put my own initials under my father's name in it)—and looking with Mary at the outline of Mont Blanc, copied from Saussure, at p. 201, and reading some of the very singular information about the Alps which it illustrates. So that Switzerland must have been at once included in the plans,—soon prosperously, and with result of all manner of good, by God's help fulfilled.

The poor modern slaves and simpletons who let themselves be dragged like cattle, or felled timber, through the countries they imagine themselves visiting, can have no conception whatever of the complex joys, and ingenious hopes, connected with the choice and arrangement of the travelling carriage in old times. The mechanical questions first, of strength—easy rolling,—steady and safe poise of persons and luggage; the general stateliness of effect to be obtained for the abashing of plebeian beholders; the cunning design and distribution of store-cellars under the seats, secret drawers under front windows, invisible pockets under padded lining, safe from dust, and accessible only by insidious slits, or necromantic valves like Aladdin's trap-door; the fitting of cushions where they would not slip, the rounding of corners for more delicate repose; the prudent attachments and springs of blinds; the perfect fitting of windows, on which

one-half the comfort of a travelling carriage really depends; and the adaptation of all these concentrated luxuries to the probabilities of who would sit where, in the little apartment which was to be virtually one's home for five or six months;—all this was an imaginary journey in itself, with every pleasure, and none of the discomfort, of practical travelling.

To all these conditions of luxury and felicity, can the modern steam-puffed tourist conceive the added ruling and culminating one—that we were never in a hurry? coupled with the correlative power of always starting at the hour we chose, and that if we weren't ready, the horses would wait? As a rule, we breakfasted at our own home time—eight; the horses were pawing and neighing at the door (under the archway, I should have said) by nine. Between nine and three,—reckoning seven miles an hour, including stoppages, for minimum pace,—we had done our forty to fifty miles of journey, sate down to dinner at four,—and I had two hours of delicious exploring by myself in the evening; ordered in punctually at seven to tea, and finishing my sketches till half-past nine,—bedtime.

On longer days of journey we started at six, and did twenty miles before breakfast, coming in for four o'clock dinner as usual. In a quite long day we made a second stop, dining at any nice village hostelry, and coming in for late tea, after doing our eighty or ninety miles. But these pushes were seldom made unless to get to some pleasant cathedral town for Sunday, or pleasant Alpine village. We never travelled on Sunday; my father and I nearly always went—as philosophers—to mass, in the morning, and my mother, in pure good-nature to us, (I scarcely ever saw in her a trace of feminine curiosity,) would join with us in some such profanity as a drive on the Corso, or the lake, in the afternoon. But we all, even my father, liked a walk in the fields better, round an Alpine châlet village.

The Black Forest! The fall of Schaffhausen! The chain of the Alps! within one's grasp for Sunday! What a Sunday, instead of customary Walworth and the Dulwich fields! My impassioned petition at last carried it, and the earliest morning saw us trotting over the bridge of

boats to Kehl, and in the eastern light I well remember watching the line of the Black Forest hills enlarge and rise, as we crossed the plain of the Rhine. "Gates of the hills;" opening for me to a new life—to cease no more, except at the Gates of the Hills whence one returns not.

And so, we reached the base of the Schwartzwald, and entered an ascending dingle; and scarcely, I think, a quarter of an hour after entering, saw our first "Swiss cottage."* How much it meant to all of us,—how much prophesied to me, no modern traveller could the least conceive, if I spent days in trying to tell him. A sort of triumphant shriek—like all the railway whistles going off at once at Clapham Junction—has gone up from the Fooldom of Europe at the destruction of the myth of William Tell. To us, every word of it was true—but mythically luminous with more than mortal truth; and here, under the black woods, glowed the visible, beautiful, tangible testimony to it in the purple larch timber, carved to exquisiteness by the joy of peasant life, continuous, motionless there in the pine shadow on its ancestral turf,—unassailed and unassailing, in the blessedness of righteous poverty, of religious peace.

The myth of William Tell is destroyed forsooth? and you have tunnelled Gothard, and filled, it may be, the Bay of Uri;—and it was all for you and your sake that the grapes dropped blood from the press of St. Jacob, and the pine club struck down horse and helm in Morgarten Glen?

Difficult enough for you to imagine, that old travellers' time when Switzerland was yet the land of the Swiss, and the Alps had never been trod by foot of man. Steam, never heard of yet, but for short fair weather crossing at sea (were there paddle packets across Atlantic? I forget). Any way, the roads by land were safe; and entered once into this mountain Paradise, we wound on through its balmy glens, past cottage after cottage on their lawns, still glistening in the dew.

The road got into more barren heights by the midday, the hills arduous; once or twice we had to wait for horses, and we were still twenty miles from Schaffhausen at sunset; it was past midnight when we reached her closed gates. The disturbed porter had the grace to open them—not quite wide enough; we carried away one of our lamps in collision with the slanting bar as we drove through the arch.

* Swiss, in character and real habit—the political boundaries are of no moment.

How much happier the privilege of dreamily entering a medieval city, though with the loss of a lamp, than the free ingress of being jammed between a dray and a tram-car at a railroad station!

It is strange that I but dimly recollect the following morning; I fancy we must have gone to some sort of church or other; and certainly, part of the day went in admiring the bow-windows projecting into the clean streets. None of us seem to have thought the Alps would be visible without profane exertion in climbing hills. We dined at four, as usual, and the evening being entirely fine, went out to walk, all of us,—my father and mother and Mary and I.

We must have still spent some time in town-seeing, for it was drawing toward sunset when we got up to some sort of garden promenade—west of the town, I believe; and high above the Rhine, so as to command the open country across it to the south and west. At which open country of low undulation, far into blue,—gazing as at one of our own distances from Malvern of Worcestershire, or Dorking of Kent,—suddenly—behold—beyond.

There was no thought in any of us for a moment of their being clouds. They were clear as crystal, sharp on the pure horizon sky, and already tinged with rose by the sinking sun. Infinitely beyond all that we had ever thought or dreamed,—the seen walls of lost Eden could not have been more beautiful to us; not more awful, round heaven, the walls of sacred Death.

It is not possible to imagine, in any time of the world, a more blessed entrance into life, for a child of such a temperament as mine. True; the temperament belonged to the age: a very few years,—within the hundred,—before that, no child could have been born to care for mountains, or for the men that lived among them, in that way. Till Rousseau's time, there had been no "sentimental" love of nature; and till Scott's, no such apprehensive love of "all sorts and conditions of men," not in the soul merely, but in the flesh. St. Bernard of La Fontaine, looking out to Mont Blanc with his child's eyes, sees above Mont Blanc the Madonna; St. Bernard of Talloires, not the Lake of Annecy, but the dead between Martigny and Aosta. But for me, the Alps and their people were alike beautiful in their snow, and their humanity; and I wanted, neither for them nor myself, sight of any thrones in heaven but the rocks, or of any spirits in heaven but the clouds.

Thus, in perfect health of life and fire of heart, not wanting to be anything but the boy I was, not wanting to have anything more than I had; knowing of sorrow only just so much as to make life serious to me, not enough to slacken in the least its sinews; and with so much of science mixed with feeling as to make the sight of the Alps not only the revelation of the beauty of the earth; but the opening of the first page of its volume,—I went down that evening from the garden-terrace of Schaffhausen with my destiny fixed in all of it that was to be sacred and useful. To that terrace, and the shore of the Lake of Geneva, my heart and faith return to this day, in every impulse that is yet nobly alive in them, and every thought that has in it help or peace.

The morning after that Sunday's eve at Schaffhausen was also cloudless, and we drove early to the falls, seeing again the chain of the Alps by morning light, and learning, at Lauffen, what an Alpine river was. Coming out of the gorge of Balstall, I got another ever memorable sight of the chain of the Alps, and these distant views, never seen by the modern traveller, taught me, and made me feel, more than the close marvels of Thun and Interlachen. It was again fortunate that we took the grandest pass into Italy,—that the first ravine of the main Alps I saw was the Via Mala, and the first lake of Italy, Como.

We took boat on the little recessed lake of Chiavenna, and rowed down the whole way of waters, passing another Sunday at Cadenabbia, and then, from villa to villa, across the lake, and across, to Como, and so to Milan by Monza.

It was then full, though early, summer time; and the first impression of Italy always ought to be in her summer. It was also well that, though my heart was with the Swiss cottager, the artificial taste in me had been mainly formed by Turner's rendering of those very scenes, in Rogers' "Italy." The "Lake of Como," the two moonlight villas, and the "Farewell," had prepared me for all that was beautiful and right in the terraced gardens, proportioned arcades, and white spaces of sunny wall, which have in general no honest charm for the English mind. But to me, they were almost native through Turner,—familiar at once, and revered. I had no idea then of the Renaissance evil in them; they were associated only with what I had been told of the "divine art" of Raphael and Leonardo, and, by my ignorance of dates,

associated with the stories of Shakespeare. Portia's villa,—Juliet's palace,—I thought to have been like these.

Protected by these monastic severities and aristocratic dignities, from the snares and disturbances of the outer world, the routine of my childish days became fixed, as of the sunrise and sunset to a nestling. It may seem singular to many of my readers that I remember with most pleasure the time when it was most regular and most solitary. The entrance of my cousin Mary into our household was coincident with the introduction of masters above described, and with other changes in the aims and employments of the day, which, while they often increased its interest, disturbed its tranquillity. The ideas of success at school or college, put before me by my masters, were ignoble and comfortless, in comparison with my mother's regretful blame, or simple praise: and Mary, though of a mildly cheerful and entirely amiable disposition, necessarily touched the household heart with the sadness of her orphanage, and something interrupted its harmony, by the difference, which my mother could not help showing between the feelings with which she regarded her niece and her child.

And although I have dwelt with thankfulness on the many joys and advantages of these secluded years, the vigilant reader will not, I hope, have interpreted the accounts rendered of them into general praise of a like home education in the environs of London. But one farther good there was in it, hitherto unspoken; that great part of my acute perception and deep feeling of the beauty of architecture and scenery abroad, was owing to the well-formed habit of narrowing myself to happiness within the four brick walls of our fifty by one hundred yards of garden; and accepting with resignation the aesthetic external surroundings of a London suburb, and, yet more, of a London chapel. For Dr. Andrews' was the Londonian chapel in its perfect type, definable as accurately as a Roman basilica,—an oblong, flat-ceiled barn, lighted by windows with semicircular heads, brick-arched, filled by small-paned glass held by iron bars, like fine threaded halves of cobwebs; galleries propped on iron pipes, up both sides; pews, well shut in, each of them, by partitions of plain deal, and neatly brass-latched deal doors, filling the barn floor, all but its two lateral straw-matted passages; pulpit, sublimely isolated, central from

sides and clear of altar rails at end; a stout, four-legged box of well-grained wainscot, high as the level of front galleries, and decorated with a cushion of crimson velvet, padded six inches thick, with gold tassels at the corners; which was a great resource to me when I was tired of the sermon, because I liked watching the rich color of the folds and creases that came in it when the clergyman thumped it.

Imagine the change between one Sunday and the next,—from the morning service in this building, attended by the families of the small shopkeepers of the Walworth Road, in their Sunday trimmings; our plumber's wife, fat, good, sensible Mrs. Goad, sat in the next pew in front of us, sternly sensitive to the interruption of her devotion by our late arrivals); fancy the change from this, to high mass in Rouen Cathedral, its nave filled by the white-capped peasantry of half Normandy!

I must here, in advance, tell the general reader that there have been, in sum, three centres of my life's thought: Rouen, Geneva, and Pisa. All that I did at Venice was by work, because her history had been falsely written before, and not even by any of her own people understood; and because, in the world of painting, Tintoret was virtually unseen, Veronese unfelt, Carpaccio not so much as named, when I began to study them; something also was due to my love of gliding about in gondolas. But Rouen, Geneva, and Pisa have been tutresses of all I know, and were mistresses of all I did, from the first moments I entered their gates.

In this journey of 1835 I first saw Rouen and Venice—Pisa not till 1840; nor could I understand the full power of any of those great scenes till much later. But for Abbeville, which is the preface and interpretation of Roueu, I was ready on that 5th of June, and felt that here was entrance for me into immediately healthy labor and joy.

For here I saw that art (of its local kind), religion, and present human life, were yet in perfect harmony. There were no dead six days and dismal seventh in those sculptured churches; there was no beadle to lock me out of them, or pew-shutter to shut me in. I might haunt them, fancying myself a ghost; peep round their pillars, like Rob Roy; kneel in them, and scandalize nobody; draw in them, and disturb none. Outside, the faithful old town gathered itself, and nestled

under their buttresses like a brood beneath the mother's wings; the quiet, uninjurious aristocracy of the newer town opened into silent streets, between self-possessed and hidden dignities of dwelling, each with its courtyard and richly trellised garden. The commercial square, with the main street of traverse, consisted of uncompetitive shops, such as were needful, of the native wares; cloth and hosiery spun, woven, and knitted within the walls; cheese of neighboring Neuchatel; fruit of their own gardens, bread from the fields above the green côteaux; meat of their herds, untainted by American tin; smith's work of sufficient scythe and ploughshare, hammered on the open anvil; groceries dainty, the coffee generally roasting odoriferously in the street before the door; for the modistes, perhaps a bonnet or two from Paris, the rest, wholesome dress for peasant and dame of Ponthieu. Above the prosperous, serenely busy and beneficent shop, the old dwelling-house of its ancestral masters; pleasantly carved, proudly roofed, keeping its place, and order, and recognized function, unfailing, unenlarging, for centuries. Round all, the breezy ramparts, with their long waving avenues; through all, in variously circuiting cleanness and sweetness of navigable river and active mill-stream, the green chalk-water of the Somme.

My most intense happiness have of course been among; mountains. But for cheerful, unalloyed, unwearying pleasure, the getting in sight of Abbeville on a fine summer afternoon, jumping out in the courtyard of the Hôtel de l'Europe, and rushing down the street to see St. Wulfran again before the sun was off the towers, are things to cherish the past for,—to the end.

Of Rouen, and its Cathedral, my saying remains yet to be said, if days be given me, in "Our Fathers have Told Us." The sight of them, and following journey up the Seine to Paris, then to Soissons and Rheims, determined, as aforesaid, the first centre and circle of future life-work. Beyond Rheims, at Bar-le-Duc, I was brought again within the greater radius of the Alps, and my father was kind enough to go down by Plombières to Dijon, that I might approach them by the straightest pass of Jura.

The reader must pardon my relating so much as I think he may care to hear of this journey of 1835, rather as what *used* to happen, than as limitable to that date; for it is extremely difficult for me now to separate the circumstances of any one journey from those of sub-

sequent days, in which we stayed at the same inns, with variation only from the blue room to the green, saw the same sights, and rejoiced the more in every pleasure—that it was not new.

And this latter part of the road from Paris to Geneva, beautiful without being the least terrific or pathetic, but in the most lovable and cheerful way, became afterward so dear and so domestic to me, that I will not attempt here to check my gossip of it.

We used always to drive out of the yard of La Cloche at Dijon in early morning—seven, after joyful breakfast at half-past six. The small saloon on the first floor to the front had a bedroom across the passage at the west end of it, whose windows commanded the cathedral towers over a low roof on the opposite side of the street. This was always mine, and its bed was in an alcove at the back, separated only by a lath partition from an extremely narrow passage leading from the outer gallery to Anne's room. It was a delight for Anne to which I think she looked forward all across France, to open a little hidden door from this passage, at the back of the alcove exactly above my pillow, and surprise—or wake, me in the morning.

I think I only remember once starting in rain. Usually the morning sun shone through the misty spray and far-thrown diamonds of the fountain in the southeastern suburb, and threw long poplar shadows across the road to Genlis.

Genlis, Auxonne, Dole, Mont-sous-Vaudrey—three stages of 12 or 14 kilometers each, two of 18; in all about 70 kilometres = 42 miles, from Dijon gate to Jura foot—we went straight for the hills always lunching on French plums and bread.

Level plain of little interest to Auxonne. I used to wonder how any mortal creature could be content to live within actual sight of Jura, and never go to see them, all their lives! At Auxonne, cross the Saône, wide and beautiful in clear shallows of green stream—little more, yet, than a noble mountain torrent; one saw in an instant it came from Jura. Another hour of patience, and from the broken yellow limestone slopes of Dole—there, at last, they were—the long blue surges of them fading as far as eye could see to the south, more abruptly near to the northeast, where the bold outlier, almost island, of them, rises like a precipitous Wrekin, above Salins. Beyond Dole, a new wildness comes into the more undulating country, notable chiefly for its clay-built cottages with enormously high thatched

gables of roof. Strange, that I never inquired into the special reason
of that form, nor looked into a single cottage to see the mode of its
inhabitation!

The village, or rural town, of Poligny, clustered out of well-built
old stone houses, with gardens and orchards; and gathering at the
midst of it into some pretence or manner of a street, straggles along
the roots of Jura at the opening of a little valley, which in Yorkshire
or Derbyshire limestone would have been a gorge between nodding
cliffs, with a pretty pattering stream at the bottom; but, in Jura is a far
retiring theatre of rising terraces, with bits of field and garden get-
ting foot on them at various heights; a spiry convent in its hollow,
and well-built little nests of husbandry-building set in corners of
meadow, and on juts of rock;—no stream, to speak of, nor springs in
it, nor the smallest conceivable reason for its being there, but that
God made it.

"Far" retiring, I said,—perhaps a mile into the hills from the
outer plain, by half a mile across, permitting the main road from
Paris to Geneva to serpentine and zigzag capriciously up the cliff ter-
races with innocent engineering, finding itself every now and then
where it had no notion of getting to, and looking, in a circumflex of
puzzled level, where it was to go next;—retrospect of the plain of
Burgundy enlarging under its backward sweeps, till at last, under a
broken bit of steep final crag, it got quite up the side, and out over
the edge of the ravine, where said ravine closes as unreasonably as it
had opened, and the surprised traveller finds himself, magically as if
he were Jack of the Beanstalk, in a new plain of an upper world. A
world of level rock, breaking at the surface into yellow soil, capable
of scanty, but healthy, turf, and sprinkled copse and thicket; with
here and there, beyond, a blue surge of pines, and over those, if the
evening or morning were clear, always one small bright silvery like-
ness of a cloud.

These first tracts of Jura differ in many pleasant ways from the
limestone levels round Ingleborough, which are their English types.
The Yorkshire moors are mostly by a hundred or two feet higher, and
exposed to drift of rain under violent, nearly constant, wind. They
break into wide fields of loose blocks, and rugged slopes of shale; and
are mixed with sands and clay from the millstone grit, which nourish
rank grass, and lodge in occasional morass: the wild winds also forbid-

ding any vestige or comfort of tree, except here and there in a sheltered nook of new plantation. But the Jura sky is as calm and clear as that of the rest of France; if the day is bright on the plain, the bounding hills are bright also; the Jura rock, balanced in the make of it between chalk and marble, weathers indeed into curious rifts and furrows, but rarely breaks loose, and has long ago clothed itself either with forest flowers, or with sweet short grass, and all blossoms that love sunshine. The pure air, even on this lower ledge of a thousand feet above sea, cherishes their sweetest scents and liveliest colors, and the winter gives them rest under thawless serenity of snow.

A still greater and stranger difference exists in the system of streams. For all their losing themselves and hiding, and intermitting, their presence is distinctly felt on a Yorkshire moor; one sees the places they have been in yesterday, the wells where they will flow after the next shower, and a tricklet here at the bottom of a crag, or a tinkle there from the top of it, is always making one think whether this is one of the sources of Aire, or rooflets of Ribble, or beginnings of Bolton Strid, or threads of silver which are to be spun into Tees.

But no whisper, nor murmur, nor patter, nor song of streamlet disturbs the enchanted silence of open Jura. The rain-cloud clasps her cliffs, and floats along her fields; it passes, and in an hour the rocks are dry, and only beads of dew left in the Alchemilla leaves,—but of rivulet, or brook,—no vestige yesterday, or to-day, or to-morrow. Through unseen fissures and filmy crannies the waters of cliff and plain have alike vanished, only far down in the depths of the main valley glides the strong river, unconscious of change.

My times of happiness had always been when *nobody* was thinking of me; and the main discomfort and drawback to all proceedings and designs, the attention and interference of the public—represented by my mother and the gardener. The garden was no waste place to me, because I did not suppose myself an object of interest either to the ants or the butterflies; and the only qualification of the entire delight of my evening walk at Champagnole or St. Laurent was the sense that my father and mother *were* thinking of me, and would be frightened if I was five minutes late for tea.

I don't mean in the least that I could have done without them. They were, to me, much more than Carlyle's wife to him; and if Carlyle had written, instead of, that he wanted Emerson to think of him in America, that he wanted his father and mother to be thinking of him at Ecclefechan, it had been well. But that the rest of the world was waste to him unless he had admirers in it, is a sorry state of sentiment enough; and I am somewhat tempted, for once, to admire the exactly opposite temper of my own solitude. My entire delight was in observing without being myself noticed,—if I could have been invisible, all the better. I was absolutely interested in men and their ways, as I was interested in marmots and chamois, in tomtits and trout. If only they would stay still and let me look at them, and not get into their holes and up their heights. The living inhabitation of the world—the grazing and nesting in it,—the spiritual power of the air, the rocks, the waters,—to be in the midst of it, and rejoice and wonder at it, and help it if I could,—happier if it needed no help of mine,—this was the essential love *of Nature* in me, this the root of all that I have usefully become, and the light of all that I have rightly learned.

On the journey of 1887, when I was eighteen, I felt, for the last time, the pure childish love of nature which Wordsworth so idly takes for an intimation of immortality. We went down by the North Road, as usual; and on the fourth day arrived at Catterick Bridge, where there is a clear pebble-bedded stream, and both west and east some rising of hills, foretelling the moorlands and dells of upland Yorkshire; and there the feeling came back to me—as it could never return more.

It is a feeling only possible to youth, for all care, regret, or knowledge of evil destroys it; and it requires also the full sensibility of nerve and blood, the conscious strength of heart, and hope; not but that I suppose the purity of youth may feel what is best of it even through sickness and the waiting for death; but only in thinking death itself God's sending.

In myself, it has always been quite exclusively confined to *wild*, that is to say, wholly natural places, and especially to scenery animated by streams, or by the sea. The sense of the freedom, sponta-

neous, unpolluted power of nature was essential in it. I enjoyed a lawn, a garden, a daisied field, a quiet pond, as other children do; but by the side of Wandel, or on the downs of Sandgate, or by a Yorkshire stream under a cliff, I was different from other children, that ever I have noticed; but the feeling cannot be described by any of us that have it. Wordsworth's "haunted me like a passion" is no description of it, for it is not *like*, but *is*, a passion; the point is to define how it *differs* from other passions,—what sort of human, pre-eminently human, feeling it is that loves a stone for a stone's sake, and a cloud for a cloud's. A monkey loves a monkey for a monkey's sake, and a nut for the kernel's, but not a stone for a stone's. I took stones for bread, but not certainly at the Devil's bidding.

I was different, be it once more said, from other children even of my own type, not so much in the actual nature of the feeling, but in the mixture of it. I had, in my little clay pitcher, vialfuls, as it were, of Wordsworth's reverence, Shelley's sensitiveness, Turner's accuracy, all in one. A snowdrop was to me, as to Wordsworth, part of the Sermon on the Mount; but I never should have written sonnets to the calandine, because it is of a coarse yellow, and imperfect form. With Shelley, I loved blue sky and blue eyes, but never in the least confused the heavens with my own poor little Psychidion. And the reverence and passion were alike kept in their places by the constructive Turnerian element; and I did not weary myself in wishing that a daisy could see the beauty of its shadow, but in trying to draw the shadow rightly, myself.

But so stubborn and chemically inalterable the laws of the pre-scription were, that now, looking back from 1886 to that brook shore of 1887, whence I could see the whole of my youth, I find myself in nothing whatsoever *changed*. Some of me is dead, more of me stronger. I have learned a few things, forgotten many; in the total of me, I am but the same youth, disappointed and rheumatic.

And in illustration of this stubbornness, not by stiffening of the wood with age, but in the structure of the pith, let me insist a minute or two more on the curious joy I felt in 1887 in returning to the haunts of boyhood. No boy could possibly have been more excited than I was by seeing Italy and the Alps; neither boy nor man ever knew better the difference between a Cumberland cottage and Venetian palace, or a Cumberland stream and the Rhone:—my very

knowledge of this difference will be found next year expressing itself in the first bit of promising literary work I ever did; but after all the furious excitement and wild joy of the Continent, the coming back to a Yorkshire stream-side felt like returning to heaven. We went on into well-known Cumberland; my father took me up Scawfell and Helvellyn, with a clever Keswick guide, who knew mineralogy, Mr. Wright; and the summer passed beneficently and peacefully.

I used to fancy that everybody would like clouds and rocks as well as I did, if once told to look at them; whereas, after fifty years of trial, I find that is not so, even in modern days; having long ago known that, in ancient ones, the clouds and mountains, which have been life to me, were mere inconvenience and horror to most of mankind.

In my needful and fixed resolve to set the facts down continuously, leaving the reader to his reflections on them, I am slipping a little too fast over the surfaces of things; and it becomes at this point desirable that I should know, or at least try to guess, something of what the reader's reflections *are*! and whether in the main he is getting at the sense of the facts I tell him.

Does he think me a lucky or unlucky youth, I wonder? Commendable, on the whole, and exemplary—or the reverse? Of promising gifts—or merely glitter of morning, to pass at noon? I ask him at this point, because several letters from pleased acquaintances have announced to me, of late, that they have obtained quite new lights upon my character from these jottings, and like me much better than they ever did before. Which was not the least the effect I intended to produce on them; and which moreover is the exact opposite of the effect on my own mind of meeting myself, by turning back, face to face.

On the contrary, I suffer great pain, and shame, in perceiving with better knowledge the little that I was, and the much that I lost— of time, chance, and—duty, (a duty missed is the worst of loss); and I cannot in the least understand what my acquaintances have found, in anything hitherto told them of my childhood, more amiable than

they might have guessed of the author of "Time and Tide," or "Unto This Last."

The diary says, "Introduced to-day to the man who beyond all doubt is the greatest of the age; greatest in every faculty of the imagination, in every branch of scenic* knowledge; at once the painter and poet of the day, J. M. W. Turner. Everybody had described him to me as coarse, boorish, unintellectual, vulgar. This I knew to be impossible. I found in him a somewhat eccentric, keen-mannered, matter-of-fact, English-minded—gentleman: good-natured evidently, bad-tempered evidently, hating humbug of all sorts, shrewd, perhaps a little selfish, highly intellectual, the powers of the mind not brought out with any delight in their manifestation, or intention of display, but flashing out occasionally in a word or a look."

Pretty close, that, and full, to be seen at a first glimpse, and set down the same evening.

Curiously, the drawing of Kenilworth was one of those that came out of Mr. Griffith's folio after dinner; and I believe I must have talked some folly about it, as being "a leading one of the England series;" which would displease Turner greatly. There were few thing he hated more than hearing people gush about particular drawings. He knew it merely meant they could not see the others.

Anyhow, he stood silent; the general talk went on as if he had not been there. He wished me good-night kindly and I did not see him again till I came back from Rome.

If he had but asked me to come and see him the next day! shown me a pencil sketch, and let me see him lay a wash! He would have saved me ten years of life, and would not have been less happy in the close of his own. One can only say, Such things are never to be; every soul of us has to do its fight with the Untoward, and for itself discover the Unseen.

It began to occur to me that perhaps even in the artifice of Turner there might be more truth than I had understood. I was by this time

*Meaning, I suppose, knowledge of what could rightly be represented or composed as a scene.

very learned in *his* principles of composition; but it seemed to me that in these later subjects Nature herself was composing with him.

Considering of these matters, one day on the road to Norwood, I noticed a bit of ivy round a thorn stem, which seemed, even to my critical judgment, not ill "composed;" and proceeded to make a light and shade pencil study of it in my gray paper pocket-book, carefully, as if it had been a bit of sculpture, liking it more and more as I drew. When it was done, I saw that I had virtually lost all my time since I was twelve years old, because no one had ever told me to draw what was really there! All my time, I mean, given to drawing as an art; of course I had the records of places, but had never seen the beauty of anything, not even of a stone—how much less of a leaf!

I was neither so crushed nor so elated by the discovery as I ought to have been, but it ended the chrysalid days. Thenceforward my advance was steady, however slow.

This must have been in May, and a week or two afterward I went up for my degree, but find no entry of it. I only went up for a pass, and still wrote Latin so badly that there was a chance of my *not* passing! but the examiners forgave it because the divinity, philosophy, and mathematics were all above the average; and they gave me a complimentary double-fourth.

When I was sure I had got through, I went out for a walk in the fields north of New College, (since turned into the Parks,) happy in the sense of recovered freedom, but extremely doubtful to what use I should put it. There I was, at two and twenty, with such and such powers, all second-rate except the analytic ones, which were as much in embryo as the rest, and which I had no means of measuring; such and such likings, hitherto indulged rather against conscience; and a dim sense of duty to myself, my parents, and a daily more vague shadow of Eternal Law.

What should I be, or do! my utterly indulgent father ready to let me do anything; with my room always luxuriously furnished in his house,—my expenses paid if I chose to travel. I was not heartless enough, yet, to choose to do that, alone. Perhaps it may deserve some dim praise that I never seriously thought of leaving my father and mother to explore foreign countries; and certainly the fear of grieving them was intermingled more or less with all my

thoughts; but then, I did not much *want* to explore foreign countries. I had not the least love of adventure, but liked to have comfortable rooms always ordered, and a three-course dinner ready by four o'clock. Although no coward under circumstances of accidental danger, I extremely objected to any vestige of danger as a continuous element in one's life. I would not go to India for fear of tigers, nor to Russia for fear of bears, nor to Peru for fear of earthquakes; and finally, though I had no rightly glowing or grateful affection for either father or mother, yet as they could not well do without me, so also I found I was not altogether comfortable without *them*.

So for the present, we planned a summer-time in Switzerland, not of travelling, but chiefly stay in Chamouni, to give me mountain air, and the long-coveted power of examining the Mont Blanc rocks accurately. My mother loved Chamouni nearly as much as I; but this plan was of severe self-denial to my father, who did not like snow, nor wooden-walled rooms.

But he gave up all his own likings for me, and let me plan the stages through France as I chose, by Rouen, Chartres, Fontainebleau, and Auxerre. A pencil-sketch or two at first show only want of faith in my old manner, and more endeavor for light and shade, futile enough. The flat cross-country between Chartres and Fontainebleau, with an oppressive sense of Paris to the north, fretted me wickedly; when we got to the Fountain of Fair Water I lay feverishly wakeful through the night, and was so heavy and ill in the morning that I could not safely travel, and fancied some bad sickness was coming on. However, toward twelve o'clock the inn people brought me a little basket of wild strawberries; and they refreshed me, and I put my sketch-book in pocket and tottered out, though still in an extremely languid and woe-be-gone condition; and getting into a cart-road among some young trees, where there was nothing to see but the blue sky through thin branches, lay down on the bank by the roadside to see if I could sleep. But I couldn't, and the branches against the blue sky began to interest me, motionless as the branches of a tree of Jesse on a painted window.

Feeling gradually somewhat livelier, and that I wasn't going to die this time, and be buried in the sand, though I couldn't for the present walk any farther, I took out my book, and began to draw a little aspen tree, on the other side of the cart-road, carefully.

In the spare hour of one sunny but luckless day, the fancy took us to look into the Scuola di San Rocco. Hitherto, in hesitating conjectures of what might have been, I have scarcely ventured to wish, gravely, that it *had* been. But, very earnestly, I should have bid myself that day keep *out* of the School of St. Roch, had I known what was to come of my knocking at its door. But for that porter's opening, I should (so far as one can ever know what they should) have written, "The Stones of Chamouni," instead of "The Stones of Venice;" and the "Laws of Fésole," in the full code of them, before beginning to teach in Oxford: and I should have brought out in full distinctness and use what faculty I had of drawing the human face and form with true expression of their higher beauty.

But Tintoret swept me away at once into the "mare maggiore" of the schools of painting which crowned the power and perished in the fall of Venice; so forcing me into the study of the history of Venice herself; and through that into what else I have traced or told of the laws of national strength and virtue. I am happy in having done this so that the truth of it must stand; but it was not my own proper work; and even the sea-born strength of Venetian painting was beyond my granted fields of fruitful exertion. Its continuity and felicity became thenceforward impossible, and the measure of my immediate success irrevocably shortened.

I had two distinct instincts to be satisfied, rather than ends in view, as I wrote day by day with higher-kindled feeling the second volume of "Modern Painters." The first, to explain to myself, and then demonstrate to others, the nature of that quality of beauty which I now saw to exist through all the happy conditions of living organism; and down to the minutest detail and finished material structure naturally produced. The second, to explain and illustrate the power of two schools of art unknown to the British public, that of Angelico in Florence, and Tintoret in Venice.

I have no knowledge, and can form no conjecture, of the extent to which the book in either direction accomplished its purpose. It is usually read only for its pretty passages; its theory of beauty is scarcely ever noticed,—its praise of Tintoret has never obtained the purchase of any good example of him for the National Gallery. But I

permit myself—perhaps with vain complacency—the thought that I have had considerable share in the movement which led to the useful work of the Arundel Society in Italy, and to the enlargement of the National collection by its now valuable series of fourteenth-century religious paintings.

I have to say that half my power of ascertaining facts of any kind connected with the arts, is in my stern habit of doing the thing with my own hands till I know its difficulty; and though I have no time nor wish to acquire showy skill in anything, I make myself clear as to what the skill means, and is. Thus, when I had to direct road-making at Oxford, I sate, myself, with an iron-masked stone-breaker, on his heap, to break stones beside the London road, just under Iffley Hill, till I knew how to advise my too impetuous pupils to effect their purposes in that matter, instead of breaking the heads of their hammers off, (a serious item in our daily expenses.) I learned from an Irish street crossing-sweeper what he could teach me of sweeping; but found myself in that matter nearly his match, from my boy-gardening; and again and again I swept bits of St. Giles' foot-pavements, showing my corps of subordinates how to finish into depths of gutter. I worked with a carpenter until I could take an even shaving six feet long off a board; and painted enough with properly and delightfully soppy green paint to feel the master's superiority in the use of a blunt brush. But among all these and other such studentships, the reader will be surprised, I think, to hear seriously, that the instrument I finally decided to be the most difficult to manage was the trowel. For accumulated months of my boy's life I watched bricklaying and paving;* but when I took the trowel into my own hand, abandoned at once all hope of attaining the least real skill with it, unless I gave up all thoughts of any future literary or political career. But the quite happiest bit of manual work I ever did was for my mother in the old inn at Sixt, where she alleged the stone staircase to have become unpleasantly dirty, since

*Of our pavior friends, Mr. and Mrs. Duprez (*we* always spelt and pronounced Depree), of Langley, near Slough, and Gray's Inn (pronounced Grazen) Lane, in London (see the seventh number of Dilecta). The laying of the proper quantity of sand under the pavement stones being a piece of trowel-handling as subtle as spreading the mortar under a brick.

last year. Nobody in the inn appearing to think it possible to wash it, I brought the necessary buckets of water from the yard myself, poured them into beautiful image of Versailles water-works down the fifteen or twenty steps of the great staircase, and with the strongest broom I could find, cleaned every step into its corners. It was quite lovely work to dash the water and drive the mud, from each, with accumulating splash down to the next one.

In blaming myself, as often I have done, and may have occasion to do again, for my want of affection to other people, I must also express continually, as I think back about it, more and more wonder that ever anybody had any affection for *me*. I thought they might as well have got fond of a camera lucida, or an ivory foot-rule: all my faculty was merely in showing that such and such things were so; I was no orator, no actor, no painter but in a minute and generally invisible manner; and I couldn't bear being interrupted in anything I was about.

Nevertheless, some sensible grown up people *did* get to like me!—the best of them with a protective feeling that I wanted guidance no less than sympathy; and the higher religious souls, hoping to lead me to the golden gates.

Already, in 1845, I had begun to distinguish Corinthian from Norman capitals, and in 1848, drew the niches and sculpture of French Gothic with precision and patience. But I had never cared for ornamental design until in 1850 or '51 I chanced, at a bookseller's in a back alley, on a little fourteenth century "Hours of the Virgin," not of refined work, but extremely rich, grotesque, and full of pure color.

The new worlds which every leaf of this book opened to me, and the joy I had, counting their letters and unravelling their arabesques as if they had all been of beaten gold,—as many of them indeed were,—cannot be told, any more than—everything else, of good, that I wanted to tell. Not that the worlds thus opening were themselves new, but only the possession of any part in them; for long and long ago I had gazed at the illuminated missals in noblemen's houses, with a wonder and sympathy deeper than I can give now; my love of toil, and of treasure, alike

getting their thirst gratified in them. For again and again I must repeat it, my nature is a worker's and a miser's; and I rejoiced, and rejoice still, in the mere quantity of chiselling in marble, and stitches in embroidery; and was never tired of numbering sacks of gold and caskets of jewels in the "Arabian Nights;" and though I am generous too, and love giving, yet my notion of charity is not at all dividing my last crust with a beggar, but riding through a town like a Commander of the Faithful, having any quantity of sequins and ducats in saddle-bags (where cavalry officers have holsters for their pistols), and throwing them round in radiant showers and hailing handfuls; with more bags to brace on when those were empty.

But now that I had a missal of my own, and could touch its leaves and turn, and even here and there understand the Latin of it, no girl of seven years old with a new doll is prouder or happier; but the feeling was something between the girl's with her doll, and Aladdin's in a new Spirit-slave to build palaces for him with jewel windows. For truly a well illuminated missal is a fairy cathedral full of painted windows, bound together to carry in one's pocket, with the music and the blessing of all its prayers besides.

I settled at Turin for the autumn.

There, one Sunday morning, I made my way in the south suburb to a little chapel which, by a dusty roadside, gathered to its unobserved door the few sheep of the old Waldensian faith who had wandered from their own pastures under Monte Viso into the worldly capital of Piedmont.

The assembled congregation numbered in all some three or four and twenty, of whom fifteen or sixteen were gray-haired women. Their solitary and clerkless preacher, a somewhat stunted figure in a plain black coat, with a cracked voice, after leading them through the languid forms of prayer which are all that in truth are possible to people whose present life is dull and its terrestrial future unchangeable, put his utmost zeal into a consolatory discourse on the wickedness of the wide world, more especially of the plain of Piedmont and city of Turin, and on the exclusive favor with God, enjoyed by the between nineteen and twenty-four elect members of his congregation, in the streets of Admah and Zeboim.

Myself neither cheered nor greatly alarmed by this doctrine, I walked back into the condemned city, and up into the gallery where Paul Veronese's Solomon and the Queen of Sheba glowed in full afternoon light. The gallery windows being open, there came in with the warm air, floating swells and falls of military music, from the courtyard before the palace, which seemed to me more devotional, in their perfect art, tune, and discipline, than anything. I remembered of evangelical hymns. And as the perfect color and sound gradually asserted their power on me, they seemed finally to fasten me in the old article of Jewish faith, that things done delightfully and rightly, were always done by the help and in the Spirit of God.

Of course that hour's meditation in the gallery of Turin only concluded the courses of thought which had been leading me to such end through many years. There was no sudden conversion possible to me, either by preacher, picture, or dulcimer. But that day, my evangelical beliefs were put away, to be debated of no more.

THE CHILD IN THE HOUSE[1]

Walter Pater

*A*s Florian Deleal walked, one hot afternoon, he over-took by the wayside a poor aged man, and, as he seemed weary with the road, helped him on with the burden which he carried, a certain distance. And as the man told his story, it chanced that he named the place, a little place in the neighbourhood of a great city, where Florian had passed his earliest years, but which he had never since seen, and, the story told, went forward on his journey comforted. And that night, like a reward for his pity, a dream of that place came to Florian, a dream which did for him the office of the finer sort of memory, bringing its object to mind with a great clearness, yet, as sometimes happens in dreams, raised a little above itself, and above ordinary retrospect. The true aspect of the place, especially of the house there in which he had lived as a child, the fashion of its doors, its hearths, its windows, the very scent upon the air of it, was with him in sleep for a season; only, with tints more musically blent on wall and floor, and some finer light and shadow running in and out along its curves and angles, and with all its little carvings daintier. He awoke with a sigh at the thought of almost thirty years which lay between him and that place, yet with a flutter of pleasure still within him at the fair light, as if it were a smile, upon it. And it happened that this accident of his dream was just the thing needed for the beginning of a certain design he then had in view, the noting, namely, of some things in the story of his spirit—in that process of brain-building by which we are, each one of us, what we are. With the image of the place so clear and favourable upon him, he fell to thinking of himself therein, and how his thoughts had grown up to him. In that half-spiritualised house he could watch the

[1]Published in *Macmillan's Magazine*, Aug. 1878.

better, over again, the gradual expansion of the soul which had come to be there—of which indeed, through the law which makes the material objects about them so large an element in children's lives, it had actually become a part; inward and outward being woven through and through each other into one inextricable texture—half, tint and trace and accident of homely colour and form, from the wood and the bricks; half, mere soul-stuff, floated thither from who knows how far. In the house and garden of his dream he saw a child moving, and could divide the main streams at least of the winds that had played on him, and study so the first stage in that mental journey.

The *old house*, as when Florian talked of it afterwards he always called it, (as all children do, who can recollect a change of home, soon enough but not too soon to mark a period in their lives) really was an old house; and an element of French descent in its inmates—descent from Watteau, the old court-painter, one of whose gallant pieces still hung in one of the rooms—might explain, together with some other things, a noticeable trimness and comely whiteness about everything there—the curtains, the couches, the paint on the walls with which the light and shadow played so delicately; might explain also the tolerance of the great poplar in the garden, a tree most often despised by English people, but which French people love, having observed a certain fresh way its leaves have of dealing with the wind, making it sound, in never so slight a stirring of the air, like running water.

The old-fashioned, low wainscoting went round the rooms, and up the staircase with carved balusters and shadowy angles, landing half-way up at a broad window, with a swallow's nest below the sill, and the blossom of an old pear-tree showing across it in late April, against the blue, below which the perfumed juice of the find of fallen fruit in autumn was so fresh. At the next turning came the closet which held on its deep shelves the best china. Little angel faces and reedy flutings stood out round the fire-place of the children's room. And on the top of the house, above the large attic, where the white mice ran in the twilight—an infinite, unexplored wonderland of childish treasures, glass beads, empty scent-bottles still sweet, thrum of coloured silks, among its lumber—a flat space of roof, railed round, gave a view of the neighbouring steeples; for the house, as I said, stood near a great city, which sent up heavenwards, over the twisting weather-vanes, not seldom, its beds of rolling cloud and

smoke, touched with storm or sunshine. But the child of whom I am writing did not hate the fog because of the crimson lights which fell from it sometimes upon the chimneys, and the whites which gleamed through its openings, on summer mornings, on turret or pavement. For it is false to suppose that a child's sense of beauty is dependent on any choiceness or special fineness, in the objects which present themselves to it, though this indeed comes to be the rule with most of us in later life; earlier, in some degree, we see inwardly; and the child finds for itself, and with unstinted delight, a difference for the sense, in those whites and reds through the smoke on very homely buildings, and in the gold of the dandelions at the road-side, just beyond the houses, where not a handful of earth is virgin and untouched, in the lack of better ministries to its desire of beauty.

This house then stood not far beyond the gloom and rumours of the town, among high garden-wall, bright all summer-time with Golden-rod, and brown-and-golden Wall-flower—*Flos Parietis*, as the children's Latin-reading father taught them to call it, while he was with them. Tracing back the threads of his complex spiritual habit, as he was used in after years to do, Florian found that he owed to the place many tones of sentiment afterwards customary with him, certain inward lights under which things most naturally presented themselves to him. The coming and going of travellers to the town along the way, the shadow of the streets, the sudden breath of the neighbouring gardens, the singular brightness of bright weather there, its singular darknesses which linked themselves in his mind to certain engraved illustrations in the old big Bible at home, the coolness of the dark, cavernous shops round the great church, with its giddy winding stair up to the pigeons and the bells—a citadel of peace in the heart of the trouble—all this acted on his childish fancy, so that ever afterwards the like aspects and incidents never failed to throw him into a well-recognised imaginative mood, seeming actually to have become a part of the texture of his mind. Also, Florian could trace home to this point a pervading preference in himself for a kind of comeliness and dignity, an *urbanity* literally, in modes of life, which he connected with the pale people of towns, and which made him susceptible to a kind of exquisite satisfaction in the trimness and well-considered grace of certain things and persons he afterwards met with, here and there, in his way through the world.

So the child of whom I am writing lived on there quietly; things without thus ministering to him, as he sat daily at the window with the birdcage hanging below it, and his mother taught him to read, wondering at the ease with which he learned, and at the quickness of his memory. The perfume of the little flowers of the lime-tree fell through the air upon them like rain; while time seemed to move ever more slowly to the murmur of the bees in it, till it almost stood still on June afternoons. How insignificant, at the moment, seem the influences of the sensible things which are tossed and fall and lie about us, so, or so, in the environment of early childhood. How indelibly, as we afterwards discover, they affect us; with what capricious attractions and associations they figure themselves on the white paper, the smooth wax, of our ingenuous souls, as "with lead in the rock for ever," giving form and feature, and as it were assigned house-room in our memory, to early experiences of feeling and thought, which abide with us ever afterwards, thus, and not otherwise. The realities and passions, the rumours of the greater world without, steal in upon us, each by its own special little passage-way, through the wall of custom about us; and never afterwards quite detach themselves from this or that accident, or trick, in the mode of their first entrance to us. Our susceptibilities, the discovery of our powers, manifold experiences—our various experiences of the coming and going of bodily pain, for instance—belong to this or the other well-remembered place in the material habitation—that little white room with the window across which the heavy blossoms could beat so peevishly in the wind, with just that particular catch or throb, such a sense of teasing in it, on gusty mornings; and the early habitation thus gradually becomes a sort of material shrine or sanctuary of sentiment; a system of visible symbolism interweaves itself through all our thoughts and passions; and irresistibly, little shapes, voices, accidents—the angle at which the sun in the morning fell on the pillow—become parts of the great chain wherewith we are bound.

Thus far, for Florian, what all this had determined was a peculiarly strong sense of home—so forcible a motive with all of us—prompting to us our customary love of the earth, and the larger part of our fear of death, that revulsion we have from it, as from something strange, untried, unfriendly; though life-long imprisonment, they tell you, and final banishment from home is a thing bitterer still;

the looking forward to but a short space, a mere childish *goûter* and dessert of it, before the end, being so great a resource of effort to pilgrims and wayfarers, and the soldier in distant quarters, and lending, in lack of that, some power of solace to the thought of sleep in the home churchyard, at least—dead cheek by dead cheek, and with the rain soaking in upon one from above.

So powerful is this instinct, and yet accidents like those I have been speaking of so mechanically determine it; its essence being indeed the early familiar, as constituting our ideal, or typical conception, of rest and security. Out of so many possible conditions, just this for you and that for me, brings ever the unmistakeable realisation of the delightful *chez soi*; this for the Englishman, for me and you, with the closely-drawn white curtain and the shaded lamp; that, quite other, for the wandering Arab, who folds his tent every morning, and makes his sleeping-place among haunted ruins, or in old tombs.

With Florian then the sense of home became singularly intense, his good fortune being that the special character of his home was in itself so essentially home-like. As after many wanderings I have come to fancy that some parts of Surrey and Kent are, for Englishmen, the true landscape, true home-counties, by right, partly, of a certain earthy warmth in the yellow of the sand below their gorse-bushes, and of a certain grey-blue mist after rain, in the hollows of the hills there, welcome to fatigued eyes, and never seen farther south; so I think that the sort of house I have described, with precisely those proportions of red-brick and green, and with a just perceptible monotony in the subdued order of it, for its distinguishing note, is for Englishmen at least typically home-life. And so for Florian that general human instinct was reinforced by this special home-likeness in the place his wandering soul had happened to light on, as, in the second degree, its body and earthly tabernacle; the sense of harmony between his soul and its physical environment became, for a time at least, like perfectly played music, and the life led there singularly tranquil and filled with a curious sense of self-possession. The love of security, of an habitually undisputed standing-ground or sleeping-place, came to count for much in the generation and correcting of his thoughts, and afterwards as a salutary principle of restraint in all his wanderings of spirit. The wistful yearning towards home, in absence from it, as the shadows of evening deepened, and he followed in

thought what was doing there from hour to hour, interpreted to him much of a yearning and regret he experienced afterwards, towards he knew not what, out of strange ways of feeling and thought in which, from time to time, his spirit found itself alone; and in the tears shed in such absences there seemed always to be some soul-subduing fore-taste of what his last tears might be.

And the sense of security could hardly have been deeper, the quiet of the child's soul being one with the quiet of its home, a place "inclosed" and "sealed." But upon this assured place, upon the child's assured soul which resembled it, there came floating in from the larger world without, as at windows left ajar unknowingly, or over the high garden walls, two streams of impressions, the sentiments of beauty and pain—recognitions of the visible, tangible, audible loveliness of things, as a very real and somewhat tyrannous element in them—and of the sorrow of the world, of grown people and children and animals, as a thing not to be put by in them. From this point he could trace two pre-dominant processes of mental change in him—the growth of an almost diseased sensibility to the spectacle of suffering, and, parallel with this, the rapid growth of a certain capacity of fascination by bright colour and choice form—the sweet curvings, for instance, of the lips of those who seemed to him comely persons, modulated in such delicate unison to the things they said or sang,—marking early the activity in him of a more than customary sensuousness, "the lust of the eye," as the Preacher says, which might lead him, one day, how far! Could he have foreseen the weariness of the way! In music sometimes the two sorts of impressions came together, and he would weep, to the surprise of older people. Tears of joy too the child knew, also to older people's surprise; real tears, once, of relief from long-strung, childish expectation, when he found returned at evening, with new roses in her cheeks, the little sister who had been to a place where there was a wood, and brought back for him a treasure of fallen acorns, and black crow's feathers, and his peace at finding her again near him mingled all night with some intimate sense of the distant forest, the rumour of its breezes, with the glossy blackbirds aslant and the branches lifted in them, and of the per-fect nicety of the little cups that fell. So those two elementary appre-hensions of the tenderness and of the colour in things grew apace in him, and were seen by him afterwards to send their roots back into the beginnings of life.

Let me note first some of the occasions of his recognition of the element of pain in things—incidents, now and again, which seemed suddenly to awake in him the whole force of that sentiment which Goethe has called the *Weltschmerz*, and in which the concentrated sorrow of the world seemed suddenly to lie heavy upon him. A book lay in an old book-case, of which he cared to remember one picture— a woman sitting, with hands bound behind her, the dress, the cap, the hair, folded with a simplicity which touched him strangely, as if not by her own hands, but with some ambiguous care at the hands of others—Queen Marie Antoinette, on her way to execution—we all remember David's drawing, meant merely to make her ridiculous. The face that had been so high had learned to be mute and resistless; but out of its very resistlessness, seemed now to call on men to have pity, and forbear; and he took note of that, as he closed the book, as a thing to look at again, if he should at any time find himself tempted to be cruel. Again, he would never quite forget the appeal in the small sister's face, in the garden under the lilacs, terrified at a spider lighted on her sleeve. He could trace back to the look then noted a certain mercy he conceived always for people in fear, even of little things, which seemed to make him, though but for a moment, capable of almost any sacrifice of himself. Impressible, susceptible persons, indeed, who had had their sorrows, lived about him; and this sensibility was due in part to the tacit influence of their presence, enforcing upon him habitually the fact that there are those who pass their days, as a matter of course, in a sort of "going quietly." Most poignantly of all he could recall, in unfading minutest circumstance, the cry on the stair, sounding bitterly through the house, and struck into his soul for ever, of an aged woman, his father's sister, come now to announce his death in distant India; how it seemed to make the aged woman like a child again; and, he knew not why, but this fancy was full of pity to him. There were the little sorrows of the dumb animals too—of the white angora, with a dark tail like an ermine's, and a face like a flower, who fell into a lingering sickness, and became quite delicately human in its valetudinarianism, and came to have a hundred different expressions of voice—how it grew worse and worse, till it began to feel the light too much for it, and at last, after one wild morning of pain, the little soul flickered away from the body, quite worn to death already, and now but feebly retaining it.

So he wanted another pet; and as there were starlings about the place, which could be taught to speak, one of them was caught, and he meant to treat it kindly; but in the night its young ones could be heard crying after it, and the responsive cry of the mother-bird towards them; and at last, with the first light, though not till after some debate with himself, he went down and opened the cage, and saw a sharp bound of the prisoner up to her nestlings; and therewith came the sense of remorse,—that he too was become an accomplice in moving, to the limit of his small power, the springs and handles of that great machine in things, constructed so ingeniously to play pain-fugues on the delicate nerve-work of living creatures.

I have remarked how, in the process of our brain-building, as the house of thought in which we live gets itself together, like some airy bird's-nest of floating thistle-down and chance straws, compact at last, little accidents have their consequence; and thus it happened that, as he walked one evening, a garden gate, usually closed, stood open; and lo! within, a great red hawthorn in full flower, embossing heavily the bleached and twisted trunk and branches, so aged that there were but few green leaves thereon—a plumage of tender, crimson fire out of the heart of the dry wood. The perfume of the tree had now and again reached him, in the currents of the wind, over the wall, and he had wondered what might be behind it, and was now allowed to fill his arms with the flowers—flowers enough for all the old blue-china pots along the chimney-piece, making *fête* in the children's room. Was it some periodic moment in the expansion of soul within him, or mere trick of heat in the heavily-laden summer air? But the beauty of the thing struck home to him feverishly; and in dreams all night he loitered along a magic roadway of crimson flowers, which seemed to open ruddily in thick, fresh masses about his feet, and fill softly all the little hollows in the banks on either side. Always afterwards, summer by summer, as the flowers came on, the blossom of the red hawthorn still seemed to him absolutely the reddest of all things; and the goodly crimson, still alive in the works of old Venetian masters or old Flemish tapestries, called out always from afar the recollection of the flame in those perishing little petals, as it pulsed gradually out of them, kept long in the drawers of an old cabinet. Also then, for the first time, he seemed to experience a passionateness in his relation to fair outward objects, an inexplicable

excitement in their presence, which disturbed him, and from which
he half longed to be free. A touch of regret or desire mingled all night
with the remembered presence of the red flowers, and their perfume
in the darkness about him; and the longing for some undivined,
entire possession of them was the beginning of a revelation to him,
growing ever clearer, with the coming of the gracious summer guise
of fields and trees and persons in each succeeding year, of a certain,
at times seemingly exclusive, predominance in his interests, of beau-
tiful physical things, a kind of tyranny of the senses over him.

In later years he came upon philosophies which occupied him
much in the estimate of the proportion of the sensuous and the ideal
elements in human knowledge, the relative parts they bear in it; and,
in his intellectual scheme, was led to assign very little to the abstract
thought, and much to its sensible vehicle or occasion. Such meta-
physical speculation did but reinforce what was instinctive in his way
of receiving the world, and for him, everywhere, that sensible vehicle
or occasion became, perhaps only too surely, the necessary concomi-
tant of any perception of things, real enough to be of any weight or
reckoning, in his house of thought. There were times when he could
think of the necessity he was under of associating all thoughts to
touch and sight, as a sympathetic link between himself and actual,
feeling, living objects; a protest in favour of real men and women
against mere grey, unreal abstractions; and he remembered gratefully
how the Christian religion, hardly less than the religion of the ancient
Greeks, translating so much of its spiritual verity into things that may
be seen, condescends in part to sanction this infirmity, if so it be, of
our human existence, wherein the world of sense is so much with us,
and welcomed this thought as a kind of keeper and sentinel over his
soul therein. But certainly, he came more and more to be unable to
care for, or think of soul but as in an actual body, or of any world but
that wherein are water and trees, and where men and women look, so
or so, and press actual hands. It was the trick even his pity learned,
fastening those who suffered in anywise to his affections by a kind of
sensible attachments. He would think of Julian, fallen into incurable
sickness, as spoiled in the sweet blossom of his skin like pale amber,
and his honey-like hair; of Cecil, early dead, as cut off from the lilies,
from golden summer days, from women's voices; and then what com-
forted him a little was the thought of the turning of the child's flesh

to violets in the turf above him. And thinking of the very poor, it was not the things which most men care most for that he yearned to give them; but fairer roses, perhaps, and power to taste quite as they will, at their ease and not task-burdened, a certain desirable, clear light in the new morning, through which sometimes he had noticed them, quite unconscious of it, on their way to their early toil.

So he yielded himself to these things, to be played upon by them like a musical instrument, and began to note with deepening watchfulness, but always with some puzzled, unutterable longing in his enjoyment, the phases of the seasons and of the growing or waning day, down even to the shadowy changes wrought on bare wall or ceiling—the light cast up from the snow, bringing out their darkest angles; the brown light in the cloud, which meant rain; that almost too austere clearness, in the protracted light of the lengthening day, before warm weather began, as if it lingered but to make a severer workday, with the school-books opened earlier and later; that beam of June sunshine, at last, as he lay awake before the time, a way of gold-dust across the darkness; all the humming, the freshness, the perfume of the garden seemed to lie upon it—and coming in one afternoon in September, along the red gravel walk, to look for a basket of yellow crab-apples left in the cool, old parlour, he remembered it the more, and how the colours struck upon him, because a wasp on one bitten apple stung him, and he felt the passion of sudden, severe pain. For this too brought its curious reflexions; and, in relief from it, he would wonder over it—how it had then been with him—puzzled at the depth of the charm or spell over him, which lay, for a little while at least, in the mere absence of pain; once, especially, when an older boy taught him to make flowers of sealing-wax, and he had burnt his hand badly at the lighted taper, and been unable to sleep. He remembered that also afterwards, as a sort of typical thing—a white vision of heat about him, clinging closely, through the languid scent of the ointments put upon the place to make it well.

Also, as he felt this pressure upon him of the sensible world, then, as often afterwards, there would come another sort of curious questioning how the last impressions of eye and ear might happen to him, how they would find him—the scent of the last flower, the soft yellowness of the last morning, the last recognition of some object of affection, hand or voice; it could not be but that the latest look of

the eyes, before their final closing, would be strangely vivid; one would go with the hot tears, the cry, the touch of the wistful bystander, impressed how deeply on one! or would it be, perhaps, a mere frail retiring of all things, great or little, away from one, into a level distance?

For with this desire of physical beauty mingled itself early the fear of death—the fear of death intensified by the desire of beauty. Hitherto he had never gazed upon dead faces, as sometimes, afterwards, at the *Morgue* in Paris, or in that fair cemetery at Munich, where all the dead must go and lie in state before burial, behind glass windows, among the flowers and incense and holy candles—the aged clergy with their sacred ornaments, the young men in their dancing-shoes and spotless white linen—after which visits, those waxen, resistless faces would always live with him for many days, making the broadest sunshine sickly. The child had heard indeed of the death of his father, and how, in the Indian station, a fever had taken him, so that though not in action he had yet died as a soldier; and hearing of the "resurrection of the just," he could think of him as still abroad in the world, somehow, for his protection—a grand, though perhaps rather terrible figure, in beautiful soldier's things, like the figure in the picture of Joshua's Vision in the Bible—and of that, round which the mourners moved so softly, and afterwards with such solemn singing, as but a wornout garment left at a deserted lodging. So it was, until on a summer day he walked with his mother through a fair churchyard. In a bright dress he rambled among the graves, in the gay weather, and so came, in one corner, upon an open grave for a child—a dark space on the brilliant grass—the black mould lying heaped up round it, weighing down the little jewelled branches of the dwarf rose-bushes in flower. And therewith came, full-grown, never wholly to leave him, with the certainty that even children do sometimes die, the physical horror of death, with its wholly selfish recoil from the association of lower forms of life, and the suffocating weight above. No benign, grave figure in beautiful soldier's things any longer abroad in the world for his protection! only a few poor, piteous bones; and above them, possibly, a certain sort of figure he hoped not to see. For sitting one day in the garden below an open window, he heard people talking, and could not but listen, how, in a sleepless hour, a sick woman had seen one of the dead sitting beside

her, come to call her hence; and from the broken talk evolved with much clearness the notion that not all those dead people had really departed to the churchyard, nor were quite so motionless as they looked, but led a secret, half-fugitive life in their old homes, quite free by night, though sometimes visible in the day, dodging from room to room, with no great goodwill towards those who shared the place with them. All night the figure sat beside him in the reveries of his broken sleep, and was not quite gone in the morning—an odd, irreconcileable new member of the household, making the sweet familiar chambers unfriendly and suspect by its uncertain presence. He could have hated the dead he had pitied so, for being thus. Afterwards he came to think of those poor, home-returning ghosts, which all men have fancied to themselves—the *revenants*—pathetically, as crying, or beating with vain hands at the doors, as the wind came, their cries distinguishable in it as a wilder inner note. But, always making death more unfamiliar still, that old experience would ever, from time to time, return to him; even in the living he sometimes caught its likeness; at any time or place, in a moment, the faint atmosphere of the chamber of death would be breathed around him, and the image with the bound chin, the quaint smile, the straight, stiff feet, shed itself across the air upon the bright carpet, amid the gayest company, or happiest communing with himself.

To most children the sombre questionings to which impressions like these attach themselves, if they come at all, are actually suggested by religious books, which therefore they often regard with much secret distaste, and dismiss, as far as possible, from their habitual thoughts as a too depressing element in life. To Florian such impressions, these misgivings as to the ultimate tendency of the years, of the relationship between life and death, had been suggested spontaneously in the natural course of his mental growth by a strong innate sense for the soberer tones in things, further strengthened by actual circumstances; and religious sentiment, that system of biblical ideas in which he had been brought up, presented itself to him as a thing that might soften and dignify, and light up as with a "lively hope," a melancholy already deeply settled in him. So he yielded himself easily to religious impressions, and with a kind of mystical appetite for sacred things; the more as they came to him through a saintly person who loved him tenderly, and believed that

this early pre-occupation with them already marked the child out for a saint. He began to love, for their own sakes, church lights, holy days, all that belonged to the comely order of the sanctuary, the secrets of its white linen, and holy vessels, and fonts of pure water; and its hieratic purity and simplicity became the type of something he desired always to have about him in actual life. He pored over the pictures in religious books, and knew by heart the exact mode in which the wrestling angel grasped Jacob, how Jacob looked in his mysterious sleep, how the bells and pomegranates were attached to the hem of Aaron's vestment, sounding sweetly as he glided over the turf of the holy place. His way of conceiving religion came then to be in effect what it ever afterwards remained—a sacred history indeed, but still more a sacred ideal, a transcendent version or representation, under intenser and more expressive light and shade, of human life and its familiar or exceptional incidents, birth, death, marriage, youth, age, tears, joy, rest, sleep, waking—a mirror, towards which men might turn away their eyes from vanity and dullness, and see themselves therein as angels, with their daily meat and drink, even, become a kind of sacred transaction—a complementary strain or burden, applied to our every-day existence, whereby the stray snatches of music in it re-set themselves, and fall into the scheme of some higher and more consistent harmony. A place adumbrated itself in his thoughts, wherein those sacred personalities, which are at once the reflex and the pattern of our nobler phases of life, housed themselves; and this region in his intellectual scheme all subsequent experience did but tend still further to realise and define. Some ideal, hieratic persons he would always need to occupy it and keep a warmth there. And he could hardly understand those who felt no such need at all, finding themselves quite happy without such heavenly companionship, and sacred double of their life, beside them.

Thus a constant substitution of the typical for the actual took place in his thoughts. Angels might be met by the way, under English elm or beech-tree; mere messengers seemed like angels, bound on celestial errands; a deep mysticity brooded over real meetings and partings; marriages were made in heaven; and deaths also, with hands of angels thereupon, to bear soul and body quietly asunder, each to its appointed rest. All the acts and accidents of daily life borrowed a

sacred colour and significance; the very colours of things became themselves weighty with meanings like the sacred stuffs of Moses' tabernacle, full of penitence or peace. Sentiment, congruous in the first instance only with those divine transactions, the deep, effusive unction of the House of Bethany, was assumed as the due attitude for the reception of our every-day existence; and for a time he walked through the world in a sustained, not unpleasurable awe, generated by the habitual recognition, beside every circumstance and event of life, of its celestial correspondent.

Sensibility—the desire of physical beauty—a strange biblical awe, which made any reference to the unseen act on him like solemn music—these qualities the child took away with him, when, at about the age of twelve years, he left the old house, and was taken to live in another place. He had never left home before, and, anticipating much from this change, had long dreamed over it, jealously counting the days till the time fixed for departure should come; had been a little careless about others even, in his strong desire for it—when Lewis fell sick, for instance, and they must wait still two days longer. At last the morning came, very fine; and all things—the very pavement with its dust, at the roadside—seemed to have a white, pearl-like lustre in them. They were to travel by a favourite road on which he had often walked a certain distance, and on one of those two prisoner days, when Lewis was sick, had walked farther than ever before, in his great desire to reach the new place. They had started and gone a little way when a pet bird was found to have been left behind, and must even now—so it presented itself to him—have already all the appealing fierceness and wild self-pity at heart of one left by others to perish of hunger in a closed house; and he returned to fetch it, himself in hardly less stormy distress. But as he passed in search of it from room to room, lying so pale, with a look of meekness in their denudation, and at last through that little, stripped white room, the aspect of the place touched him like the face of one dead; and a clinging back towards it came over him, so intense that he knew it would last long, and spoiling all his pleasure in the realisation of a thing so eagerly anticipated. And so, with the bird found, but himself in an agony of home-sickness, thus capriciously sprung up within him, he was driven quickly away, far into the rural distance, so fondly speculated on, of that favourite country-road.

INSIDE OUT

An Essay in the Psychology
and Aesthetic Appeal of Space

Adrian Stokes

To Margaret

Preface

IN THE NURSERY, that is where to find the themes of human nature: the rest is 'working-out', though it be also the real music. But if we want the heart of the matter we must go back to the themes however bare, to the matchless mental suffering, for instance, of seventeen-months-old Christine, who said: 'Mum, mum, mum, mum, mum' . . . continually in a deep voice for at least three days.[1] I am of the opinion that in entering into Christine's experience imaginatively we respond more closely to the deeper sources of human action than in contemplating, say, the wide-flung doctrines of Malraux about the nature of man.

This is not a book about childhood, except for a little of my own. The 'working-out' as the title suggests, a certain relation to the external world, provides the subject.

Of a section of this book, an earlier version has appeared in *Polemic*, to whose editor acknowledgments are due.

Part I

GOING DOWN THE HILL ONE MORNING towards Lancaster Gate, my eldest brother remarked on an orange cloud in a dark sky: a thundercloud, he said. And sure enough, that afternoon there was a thunderstorm. At nearby Stanhope Gate, an old woman sold coloured balloons. It was as if the lot had burst. I think I remember well this small event since it symbolizes an exceptional happening. For once the glowering suspense, the feeling of things hardly redeemed, was contradicted by a menace that came to violent fruition. The thing was done and finished with: the storm happened and passed, and the small orange cloud had shown it was to happen. None of the other omens I can remember was either read or fulfilled as was this. The year would be 1908 or so, when I was six.

I used to single out the cars in the processional traffic on the road round the park, and count them. Their cautious, noisy explorations without an objective, without an arrival point, a trundling round the park, helped to create the atmosphere of grinding suspense. Meanwhile, beyond the cruel railings, the scarlet horse-buses with Tatcho advertisements roared down Bayswater Road. The railings were cruel, I think, because of the tramps who sat on seats outside, in waste-paper and drowsy filth: and whatever was railed within the park, suggested a burning-cold, a searing prohibition against those who would slink away into the iron ivyness of copse or plantation. Other single railings were isolated in the open parts of the park. Their usefulness would seem to be confined to that of a threat against the couples who blundered in the dark, choosing an exposed and therefore isolated place in which to lie. There seemed to be no love in that love-making. To the small boy, the immersed, in-rolled couple suffered from a still greater poverty than did the single drunks who slumbered face to the sky. The evil was poverty, not crime or drink. Poverty itself was destructive. Dirt, smell and the bleary eye, all to my mind, smart and noisome activities, were the predominant performances of poverty.

I was forbidden to sit on the seats with complicated cast-iron sides frequented by the destitute. Nevertheless, regarding these seats as forlorn homes, I was fascinated, not only by the danger imputed to them, an infection, as it were, of poverty, but by the possibility of constant acts of restitution. I would therefore implore my governess,

in spite of the ban, to use these seats; and I would get behind, between the low railing at the side of the walk and the back of the seat, and imagine that I was making this last refuge, for all the bareness of board and of cold, jarring contortion of cast-iron, to 'work', whether as a ship or car or whatever purposeful vessel took my fancy.

The *underneath* of the seat, at any rate, was my discovery, this space between the seat and the low rail in front of the grass, almost roofed by the sloping of the seat's back. Those who had forbidden it, had not examined that side. Could I keep the underneath alive and thus cause the animation of the whole?

This occasional game helped me very little to endow the park and its inhabitants with health. There were vaster engines than my seat which I could not control. The machine house of the fountains, for instance, had an ominous air. A scour of mysterious steam hung over a sunken tank at the back of the engine house and was apprehended at the same time as the smell of oil and the clanking of the lethal cylinders. The cold and grinding mechanism was housed in Portland stone of a late Victorian style, both white and darkened. The fountains themselves had little grace owing to the pretentiousness of every detail of the stone lay-out. Moreover, the smell of decay was freshened by the sprayed water that dropped like pellets on the surfaces of the basins. Surplus water from the final basin poured away into the Long Water. Here was the inky-dark medium of the park suicides. My governess and I used to read outside the park police station the notices recounting, in the hope of further information which brought a reward (printed in large letters), all the crimes that had recently occurred, chiefly suicides in the Serpentine. A police description of a dead body exactly expressed my predominant impression of the park as a whole. Yet I did not altogether give up hope of infusing these remnants with life. I would return again and again to the fountains and hope against hope that the engine-house activity would spell out something good. It was indeed worse when, as so often, the fountains were not working and the water licked the lichened sides more blackly without the bombardment of pellets. To see the fountains turned on—as I often did—was a fine sight, since the spouts grew from a trickle to an inch, to a foot, to a yard, finally reaching a great height, sustained there by an eager, pumping pulse: at the summit, rainbow colours could be discerned; a thin elegant

summit sometimes torn by the wind but formed again immediately. The wind might tear off the whole summit or bend the column like a tree, but the compensating power returned in the end. This entirely mechanical restitution did not please me: the power behind it was blind, exact and faithless in the sense that it did not deal in faith. Perhaps, indeed, the relentless mounting of the fountains when they were turned on, propelled by each stroke of the very extensive engine, was really most frightening to me.

The fountains played. Dirty children rushed from basin to basin: suspicious park-keepers stalked their antics, generally from afar. The keepers had boxes scattered in the park, so that their emergence could have something of the suddenness associated with the paratroop whose landing has not been observed. The keepers carried whistles. Emergence from a telephone booth is always associated by me with the fingering of something tucked away on one side of the chest, a cold, punishing little organ that it was a positive duty to handle. When a park whistle was blown near the fountains, the shrill sound seemed to travel on an eagle journey, piercing the water pellets whose clattering was considerable. In fact, you had to shout to make yourself heard near the fountains.

We called the elderly ragamuffins and tramps of the park, 'parkees'. I had wandered away from my nurse who was chatting on the walk above the fountains. Among the basins I was seized by a pack of parkees and my shouts could not be heard even a few feet away. I managed to break loose—I had the wooden handle of a push-cart with me—and regained the nurse who had noticed nothing. In spite of my remembrance, I have little doubt that no such actual thing happened. Probably the context existed; parkees spoke to me and I had been warned against such intercourse by having the fear of being kidnapped instilled in me. But a kind of feud was invented. When the nurses and their children congregated, I would glance across at the other encampment of mothers and poor children and tramp women who seemed to watch every straying movement: and perhaps, well-armed with a stick, I would run half-way in their direction, testing the evil in comparative safety.

Sometimes the positions of the opposing camps would be reversed. We would be in the fountains, and the less intent parkees (since they always inhabited these seats) would be the objects of

apprehension as they sat on a stone seat with a curious round termination on the walk above, or in the high, disproportionate alcove on the hill, down from Victoria Gate.

The tall, disproportionate alcove, shallow, high and cold, with toddlers squirming on a low brown seat, was, and is today (though it be attributed to Wren), an image to me of blindness. This kind of ethical ugliness in the use of a classical form, particularly the cruel denial of shadow or depth in proportion to the height, afflicted me to such an extent that I think it has helped me in later life to find good architecture to be a particular symbol of life. Nearly all the monuments and buildings in the park, including the fountains, professed for me the same cruel discrimination.

It was little better with the forms of life abounding on the lake, or with the dogs allowed to race and bounce about for a liverish hour, or led to lamp-post or rail on a lead. Obscenely different in size, they fought each other, raced and wrestled. In conjunction with the drawing-room salutations of their owners, their curiosity about each other appeared particularly morbid. The animal world seemed a sheer importation, a waywardness controlled with distaste and severity.

It was the same with the birds, largely fed by hand. An old man would be feeding sparrows. Their hopping and twittering and mass scurries of flight seemed to express his own accumulated evasions.

There were the peacocks which could be watched between the bars of the railings at the side of the Long Water. These disconsolate birds would sometimes spread a tail. A keeper fed them and to him was attributed all the powers of their control.

Yet occasionally, at times of post-luncheon winter sunsets, there was an atmosphere of Nature in the park. Smoke from bonfires and a decreasing light suggested some limit to control, and the yelling of peacocks from a nook surprisingly distant, dislodged for a time an imputed curriculum.

Nevertheless, the ducks and other water-fowl seemed no less chained than the sparrows upon the neat paths. There are two gaps by the side of the Long Water, where the railings and concealing shrubbery cease, where the path comes to the edge of the water. In these two small bays the ducks are visited and fed. Even here, there is a kind of fencing, though it is in the water. The ducks enter through

gaps. The shore is edged by a sloping stone kerb. A thin line of scum, feathers, soot, twigs, laves the lower edge of the rough stones which above are whetted by the slitherings of those ducks who land to be fed. Sometimes, too, there is a collection of geese with pin-cushion foreheads, needle eyes and evident ill-temper. The easy floating of the birds on water causes the uneasy trundling and shooting necks of the birds ashore to appear painful. The swans particularly look broad and gross in this shore wrangling for crumbs. The eyes of all the birds seem to pierce their heads as the keepers' whistles pierce the fountains' spray. They have their home upon an island in the Serpentine where at night they may be self-governing, though watched, as it were, by the monotonous sentry duty of the traffic in Knightsbridge.

The swans I knew to be fierce. There were stories of a blow from a wing smashing a man's leg and of the uselessness of an opened umbrella as a guard. Sometimes they moved on the water with ruffled plumage. Once, in minatory Edwardian stateliness, a swan was seen sitting on a nest below the fountains, just to the side of the dangerous overflow from the fountains into the Long Water, a miniature eddying waterfall whose downward suction or pull was challenged, but not refuted, by the even keel of the giant bird sitting on her dry nest.

Just as in the case of the parkees, when I was older and able to row a boat I used to come as close as I dared to this waterfall-termination of the Long Water. The flow, in fact, was small. But the dangers of the park as a whole could not thus be disproved.

Where did the water go? At the other end of the lake there was a low white bridge whose several arches were perhaps not more than a foot above the level of the water. Did the water flow away here where, even a swimmer, still less a boat, could not penetrate the mystery? This white stone bridge had a certain grace: the exceedingly low arches, however, were associated in my mind with a challenge to any inquisitive and anxious head whether of water fowl or man, who tried to share the fate, whatever it might be, of the water beyond the Serpentine.

On the further side of the white bridge there was a sharp declivity and a high though meagre waterfall. I don't think that I connected this water with a flow from the Serpentine. Later, I was to hear that most of the Serpentine water passed underground and came up in the

park of Buckingham Palace. I was to be told that the Serpentine could be drained, that everything flung into it could be brought to light. All the miseries of the torn, attacked and divided mother without me and within, she who was the park and all that happened there, to be known, controlled and restored? No wonder that in many later enquiries I have sought for the clean sweep. I have had an absurd faith in the efficacy of generalization and, at times, a neurotic subservience to the behests of an apparent logic. By this would-be control I have been subservient to the same relentless animus that informed, to my mind, the face of the park.

The park, of course, was not the first desolation but it is the one I remember first, the setting down in the external world of the sum of earlier desolations. Nature, in man and beast and flower, was a thing chained and divided. It would seem that each blade of grass, smelling of London even when it grew rankest, could be examined. There were no weeds. Sheep left droppings on the grass, left them there, so it appeared, just as towards sunset some living bundle of rags would seem to be left forlorn on a green chair for the use of which a penny should have been paid.

It was not usual for us to sit on these chairs. If we did, often the ticket collector would come unseen from behind us, cutting across the grass with a town gait, with his roll of tickets and his clippers moving loosely in front of him like a sporran. This ship of the park was another examining agent.

Banked-up by gardeners, flowers were viewed through railings, a splendid array in spring near Victoria Gate, just in front of the dogs' cemetery of which you could obtain one glance from the top of a bus bound for Queen's Road. Between you and the military rows of flowers was a wide grass verge and a high railing. Nearby there was a rustic cottage. In the course of time I grew very curious concerning this and other cottages, and a well-sized house in the middle of Kensington Gardens. I had never seen anyone go in or come out, but most delicious wood smoke was often climbing from the chimneys. These cottages and their small enclosed gardens, far more than the park grass or the trees or the flowers, suggested to me the open country, unknown to me except for the landscapes I saw from the train window on the way to the seaside. Later I used to imagine myself inhabiting the house in the middle of Kensington Gardens; walking

the park in the early morning, watching the dawn and later seeing the lines of trees, an unspoilt natural panorama; living in the country in the middle of London. From adolescence onwards I did what I could with my imagination to restore the park. Standing at the Round Pond, I looked across the Long Water and conjured up the vista of an eighteenth-century park, a royal park having no essential connexion with the lives of children.

But it was dust-laden; every blade of grass was discerned for a metropolitan purpose. The sheep would leave wool on trees, a dubious trail in a well-known spot on all sides of which London traffic roared. In summer there was the clipping and a branding and a dip, down near the police station. The startled shorn bodies suggested a touch of extreme 'nature', a nakedness, an exhibitionism, even, a sudden production of the pale body, a child's amorous game, a suicide, a thousand little boys running nude into the Serpentine on a hot summer evening, allied somehow with the world of correctitude, railings and park-keepers; with parkees and violent dirt, no less.

And so, the candles of the beautiful chestnut trees were sullied and dangerous in my eyes. Only the countless blossom of the may trees with their sweet dusty town smell, seemed poised and without potential disaster. In a polite and a young form the bloom of these trees was the microcosm of the continent of endless brick where hope lay among the clustered varied chimney pots. I remember picnics under the may trees near Victoria Gate: I remember the brown osier lunch basket with osier pin like a giant hat pin, and the contents spread on the tame grass. Two older girls with their nurses used to join our party of three brothers and a nurse. Sylvia had a reddish face and Enid was pale, with freckles, green eyes and long legs. A saga about parkees was begun at those picnics. Heat glittered beyond the tossed-up may trees in flower: between the trees traffic glinted, seen from the eye-level of the grass. This circular flow of traffic served as a kind of watchful coasting on the fringes of consciousness: at times, also, as vehicles which carried correspondence to the deeper depths of the mind, bringing thence the matter for new affinities. And yet this upward, as it were, and downward movement was expressed by a steady low-lying motion along a flat surface. There is pleasure, there is life, when movement, particularly even movement in space, when the outward world at large, takes for us the form of the jagged, shift-

ing promontories of the mind. It is notable, however, that the first glimpse of the sea, that closer parallel to the tossing mind, has a meaning of limitless release: and words wrested from a life at sea ring true of the mind.

As I walked at the side of the traffic from the bridge over the Serpentine to Victoria Gate, the extended movement of vehicles would express for me the hostile, unforgiving expanse of the sky. To the left there was rough ground with a deep ditch, the railed boundary between the park and Kensington Gardens. The rough ground just beyond the ditch epitomized the depth of frustration and hostility. It was here. I think, after my brothers had gone to school, that I tried to make casual friends by joining to kick a football. Also, at the end of this bit of ground, by the path going down to the fountains, I had confronted a little girl with a doll-like face called Helen who was the sister of a boy at my kindergarten. I longed to get to know her. I think there were rows and fights with possible friends on this piece of ground, the scene of failures in early attempts at sociability. For me, other children, like the rest of the furniture of the park, were objects of potential danger. Any difference in upbringing and in routine indicated a lost soul: for I was wrapt by the prohibitions and rituals in which I was educated and in terms of which I still hoped to make ultimate restitution. Projected on to the face of the park and there apprehended, the struggle was ugly, torn, stern, harrowed and dirtied, redeemed slightly—and here figured a half-concealment of the most profound anxiety—by a morbid melodrama.

I was a happy boy. By that I mean that both elders and contemporaries have told me that I gave them the impression of being happy, healthy, energetic. From my parents I had love and great care. There were occasional screaming fits, I am told, when I used to shout without end, 'I want it all right'.

What did I want put right? I had best say the park, since there is very little else that I remember either of the pleasure or the pain. The park I remember well.

I shall soon try to give a picture of the other side of this predominant state but in a subsequent form. I shall show how a good mother was finally constructed, in the external world as well as in myself. Art has played an important rôle. This is perhaps foreshadowed by my vain scrutiny of the monuments in the park: the giant Achilles statue

at Hyde Park Corner, for instance, and, later, the Watts equestrian statue in the middle of the Long Walk. I had high hopes of the Watts because it was new; I remember it veiled and then unveiled. Such figures were to me stern yet impotent; figures of a father, then, who both attacked and had been attacked. These statues attempted to affront the sky yet they were recipients of fog, of bird droppings and of soot: they seemed unconnected with light. The Albert Memorial was of the category, with vain groupings and pseudo-sacred steps. Here was a great fuss about solid matter; here was a thing of arrest which, unlike the prohibiting railings, protested as well as forbade. It took many years for me to discover that art was not a kind of warning. What else was to be made of the sharp, pale, granite obelisk in the Long Walk, with the one word 'Alma', with two steps and a platform edged by a decorous iron chain?

I think it might have been different if I had been allowed to approach Kensington Palace, the sunken Dutch garden and the Orangery. The only time I saw the Orangery, at the age of eight or nine, I was much impressed. For some reason, probably a fear of infection in an enclosed space, this part of the gardens was rigorously out-of-bounds. Perhaps because of this, still more because of the deep impression of the Orangery and its mild historic associations, the extreme limits of Kensington Gardens on the west side had magic for me: so much so, that I found it difficult to decide where were the exact limits. A sense of the infinite informed this very restricted space to the east of Kensington Park Gardens. The wall was high, but gardens stretched on the further side: termination came gently. In the shadow of that mysterious wall there lay a flat green where organized games were played of a different order from the haphazard kicking of a ball in the body of the park. I thought of this piece of ground as outside the park, yet at the same time, inside it, like a historical association pursued into the present. I was later to take great comfort in history, as if the things of the park, as if all that was carried inside my mind, could be pinned down, arranged, comprehended.

Meanwhile the traffic circulated without the park and within. All existed in suspense, and in pieces, yet stuck together. My suffering was at least magnified by the Edwardian centre of Empire.

The best epitome of massive, meticulous incoherence provided by the park, was the Magazine at the end of the Serpentine Bridge.

Explosive powder stood stored in this building of grey brick. A sentry always marched outside, and for all I know, does so to this day. Potential murder and death were guarded with careful pageantry. Except for the sentry's footfall there was a silence about the place, the seat of the greatest potential noise. Those stronger walls held the greater danger. I delighted in the sentry: I delighted in all soldiers. He was controlling the explosive powers within by his drilled movements.

What I remember most would seem to belong to autumn and winter. But singing of birds, in spring especially, the bursting buds on the trees, were not unnoticed: even a certain ecstasy in the air in early spring. The heart was not freed for long: the overlay of town smell and dirt, the very encouragement by the onlooker of pastoral things, denied them a reality that was supreme. Railings, decorous iron chains and park-keepers controlled such marionettes. I did not know the power of the earth. A row of hyacinths growing at Victoria Gate were 'fixed' there by the authorities like the diminutive cockade in the top-hat of the coachman-like keeper of the Gate. And there was no horizon, no horizon at any time.

I associate Kensington Gardens most of all with years before I was six, Kensington Gardens rather than Hyde Park. From the time I was three until I was six, we had a very strict governess, a most patriotic Irish lady. If shoelaces came undone while out for a walk, there would be no jam for tea: if they again came undone, no cake either. This penalty fell particularly on my second elder brother to catch whom it was doubtless designed. I don't remember that it happened to me: nevertheless to this day I am extremely bad at improvising knots. After my brothers had gone to boarding school, Miss Drew was dismissed for maltreating me, so it is said, in the park. My mother has since told me that she had a letter from someone who witnessed the bad temper. I remember nothing about it: indeed, I remember little about Miss Drew except that she had a watch in the shape of a sword pinned to her breast, that she had moods of vivacity as well as of hot temper and that she painted pictures of battleships in moonlight.

After Miss Drew's time, the scene is more especially Hyde Park. My next caretaker was a Miss Harley, a morbidly religious middle-aged woman. Miss Drew had also been religious, a Catholic. But now I was alone, without my brothers, as if the war were already starting and the Edwardian world were already crashing.

I had myself read in the Old Testament and had been deeply impressed by the effrontery shown by one side or the other in every issue, and by the venomous consequences. Miss Harley used to sing me hymns. She was for me the Salvation Army of morbid streets and morbid walks. Even the park sheep looked wicked and guilty, particularly the sheep, poor, smelly and sniffing. There was, I think, no talk of Christ. Perhaps it was forbidden since I was to be brought up as a simple theist at most. An essentially bachelor omnipresence, then, a bachelor blood-and-thunder, lay upon the slight hill beyond the Rotten Row, seared with paths like slow rolling tears of shame. He was a kind man—I understood that—this witness of all park love-making, sexual crimes and suicides, the magician among park-keepers as he proved himself to be in the garden of Eden or in speaking from bushes, or in hurling stone tablets out of the clouds. 'Am I my brother's keeper?' Cain had said. That was a wicked, frightened joke of Cain's.

'Time like an ever-rolling stream, bears all her sons away.' We used to sing that hymn, the thin sounds torn by the wind. I had never seen a rolling stream. I thought of it as the low thunder of the London traffic. And Time was the gloomy sky over the park, which, by turning into night, bore away the soiled fretfulness of all happenings there each day. The park monuments, then, especially the would-be works of art, possessed in my eyes an almost masochist quality in their utter poverty; impotent under the lash of Time, borne away each night to build their grimy ugliness anew each dawn. Between Marble Arch and Albion Gate there is a kind of Gothic steeple whose function is to provide several vents of drinking water. To this globuled monstrosity in particular I attributed a horrible masochism. There lingered no romance in its poverty nor in the poor frequenters; and as I was not allowed to drink such public water, I shunned it for being something blind and grey. Here stood no source, no spring. . . . It is horrible that a flow of water, thin though the trickle, should come to represent a blindness.

But more than this. Except for that all-seeing eye, everything was blind, a skein of unseeing veins and sodden skin. Where were the eyes of those motor cars, those automobiles (under the crushed-down Renault bonnets?), those vehicles of Time itself? Vision, as well as Design, lay in the effortless sky alone.

I had the makings of a true and terrible fanatic for whom a single string of argument could trap the whole universe: I was later at one with the more inhuman speakers at Marble Arch. At another period every secret of the universe was contained for me on the walls of a big bookshop.

There were, however, rare moments when the purlieus known to me had stature. They were moments of pageantry preceded by weeks of preparation. 1910 was the year of Edward VII's funeral, 1911 of George V's coronation. I saw both processions. What stays in mind were the long thin festive poles swathed in scarlet cloth, tipped with golden spear-heads, that lined both sides of Bayswater Road. Even railings were tipped with gilt. It was not the gaudiness so much as the picking out of features, the slight rearrangement of the London for-getfulness, which gave the street a life to me. I saw, as it were, for the first time that Bayswater Road was a thoroughfare: some kind of plan appeared. But for a long time to come, apart from extreme religious fears especially for those I loved, I relied principally on the reading of history to reveal some connexion in the surrounding scene.

The coronation brought soldiers to the park; thousands were encamped. A year or two before, Miss Harley had been succeeded by a Swiss, French-speaking governess, Mathilde. I think she must have been a fairly normal girl. She brought a homesick warmth. But the park held sway, and when we ate raspberry cream-filled chocolate bar which I had been forbidden, sitting in the park on one of the forbid-den seats, my pleasure was not entirely sweet. I remember particu-larly some bedroom slippers on which had been spilt an extremely sticky spread which I liked, called Frame food jelly. This sweetness in the wrong place was agonizing. I used to wear those slippers because the nursery stood over my parents' bedroom and my father, at that time, lay fighting for his life although his immediate death had been prophesied by doctors who were crowding the house. Later, he was to watch in a dressing-gown through racing glasses, the distant pas-sage of the King's funeral, seen in the distance from the balcony of the house.

Both Mathilde and I worshipped the soldiers. For a time I clung to military pomp and discipline as a 'solution' of the park and its environs. In earlier years I had tried to order the universe by the arranging of lead soldiers. If one fell I was inconsolable.

And so, the face of the park came in part to be symbolized by a hybrid image of soldiers in scarlet jackets and by Marble Arch orators standing on soap-boxes. At this time, Mathilde and I sought the press of the crowd, in Rotten Row on a Sunday morning or around the bandstand of a summer evening. I have a pictorial, almost a Renoir-like, image—the only one—of those times, based, I have little doubt, on much later experiences. For it is night, a dark, still night with rain in the air. The speakers at Marble Arch are lit with their torches; the outer fringe of whispering couples are lit by the lamps. Where it is dense the crowd is dark. Hats are in silhouette, so too the railings behind the speakers. Beyond, unwhispering grass is black except where a beam of light turns an outer fringe to emerald, the tired-smelling grass that otherwise would have been long obscured.

A soldier in a red tunic detaches himself from the crowd, takes the path across the park, probably making for Knightsbridge barracks. I watch him going between the far-flung lamps, making for the centre of the park and, so it seems, for the centre of the night since the park symbolizes all. I watch him go, getting less scarlet. Steadied by the lamps, my thoughts follow him into an immense space; for he has reached the open space where the enfolding pulse of the traffic is best felt. The lights, both near and distant, stare: an iron urge is to be attributed both to the soldier and to the preacher. Once and for all, I now put up the railings inside myself. I have an inspired feeling of Destiny, of Duty. I will follow out the most exacting inner imperative. With consistent dutiful fire I will equal the coldness and steadiness of the lamps: with a certain inner talisman I shall part the murmuring London sea: I shall prolong a selfless path with such resolution that the astonishing hideous pile of the Hyde Park hotel, so often figuring on the limits of vision, shall fall defeated below man's horizon. . . .

Mathilde and I sought the crowds. Cross, genteel scents became familiar to me of a Sunday morning. The scene was shot with violent colour, of soldiers or perhaps of rhododendra. I think I attributed to these strong colours the power to strike, to hit out with the power of a dazzling wing.

We would often go to feed the ducks, either in the Long Water or in the Serpentine, taking bags of stale bread. I was aware of the possibilities of a certain ritual in the throwing of bread on the waters. The crumbs bobbed about and soaked; whereas the stale dry bread,

particularly the brown, I found very appetizing. It made me hungry; I grudged the food to the ducks. However, in the feeding, the interest partly lay in trying to arrange for the ducks, or for any misguided bird on the outskirts, to have a share. Geese and baleful swans were the enemies. The ducks were defenceless and kind-hearted, unmackintoshed mothers fed on sodden crumbs. Their surrounding water looked extremely desolate. Sparrows were at our feet, gulls in the air.

There was no haze of delight in this rapacious hunger. Finally, the empty bag having been burst, the paper was put to bob on the murky water in accordance with the wind. The walk home was marked by the passage underneath the Serpentine bridge. The dirty echoing tunnel with its lingering airs was cold at all times of the year. It was as if the passage lay beneath the dark water, here at its deepest according to a notice of warning. A dog would be barking like Cerberus. In view of the thunderous echoes, additional heads would have been in keeping.

I think to this obscene hole I attributed the home of the animus that tore the body of the park to shreds; the parkee spirit that made the park poor, hungry, desolate.

Each man invents a myriad states to counter his inferno. They exist abreast of the inferno; compensations, mitigations, transferences, controls, stern deletions, reparations. And so it has been with me. I have already referred to some of the priority repairs, as it were, by which an immediate patching up was attempted. But a truly exacting person, anxious to discover a reparation of even the smallest detail, is likely to construct a state parallel to that by which inferno is summed. And indeed, it is the initial imputation, in such a strong degree, of emotional states to the external world, inferno or paradiso or both at once; which characterizes the person who will primarily be an artist, even when childhood is passed. In this, however, I do not think he is peculiar, but only extreme and exacting in the use of an omnipotence commensurate with his anxiety.

Another tunnel, a long railway tunnel, the Mont Cenis, was the approach to the counter-landscape, to the rested mother, to love and life. This tunnel was the approach; not the centre of the landscape, but a symbol of rebirth.

On the near side of the tunnel there had been the Parisian evening, a wide glow, a width beyond what I knew. Then the rush through the night, the shriek of engines, like those of peacocks, through the ancient towns of Burgundy. They banished for me the engine cries of Victoria heard in Hyde Park, noises which at night had seemed deliberately to hollow an oblong trough of white upon the dark.

The Swiss mountains pointed a way in the morning. The pines too had the mountainous brow, the mountainous gesture, ranged in loftier and loftier perspective, many-armed as Siva, plated with snow.

I was prepared for Italy: I had been preparing from an early time. At the age of seven, in the years of Mathilde, I had gone to a day school. After a few terms, I started Latin grammar. I had learned from Mathilde a little French but my imagination had not been moved. I was fascinated immediately by Latin. I knew one word the first day— mensa, a table—and how to decline it. I was fascinated, deeply stirred: I can remember the scene of that first lesson, where I sat, where the desks were, where the mantelpiece was. Not that I have any gift for languages; yet I possess the image of this declension of the word 'mensa' on the first day of Latin, taught by a Miss Brown whom I liked. Of the table, for the table, by the table, each expressed by one simple word. The genitive case was the possessiveness of a simple love.

It is a scrubbed, sturdy, deal kitchen table, very bright: the fact that it is solid, that it stands on the floor is beautiful. The mensa table—or rather, a nexus of such experience, since it is most unlikely to have been in isolation—was a revolution in my life, an image the 'feel' of which corresponds with an adult image of a simple table pre- pared for an al fresco meal, the family mid-day meal under a fig tree, with a fiasco of wine on the table, olives, a cheese and bread. With one word I possessed in embryo the Virgilian scene; a robust and gracious-mother earth.

Although I continued to love Latin, and later Greek, until I came through the Mont Cenis, I did not repeat this experience so vividly.

Even as a small child I took particular note of barrel-organs, of their effect upon the neighbourhood. If their tunes were no substitute for the mensa experience yet somehow they had a connexion with it; an interest, it would seem, in another Italy, in the Baroque Italy.

From what I have attributed to the traffic in Hyde Park it will be obvious that I found in sound a most effective qualification of the visual

world. A street became *informed* for me by the sounds of a barrel-organ. Everything had a new angle of light upon it, a new arrangement with a centre pulsating like a heart. Thus the street was not only organized; it became an organism, it came alive. The images of dismemberment and anxious aridity that haunted me were not in this way dissipated: but an element of drama, even of 'healthy' catastrophe, was a relief. Aided by the pictures on my father's cigar boxes and on the barrel-organ and by visits to the pantomime, that distant, anglicized cousin of the Commedia dell 'Arte theatre, the music in the street could provide me with a variety of scenes, populated, Baroque, catastrophic.

It is now a Neapolitan tune the Italian grinds; which says: the tall casa has painted shutters and each window a painted rococo entablature, brown upon the pink stucco of the wall. Families cluster at the rickety balconies. A man beats a carpet; the flotsam floats and swims in the sunlight towards the gay washing hanging below. Under the roof there is a broad band of fresco. (Gigantic mermaids wreck the fisher boats and tritons blow blue horns.) In a window a birdcage dangles. At first I think there is but one bird, but the hops are now frequent and I see the cage is over-populated. The tiny movements are so vivid that the great damp sheets which hang from the side of the balcony appear grey, and the bundle between the iron bars, not a little girl. You were young then too, and over the clambering terraces of houses, each with a flat square roof, you had arranged a cord that joined you to my house, a little higher up on the other side of the valley. By jerking this cord we could exchange exciting messages, words which the roar of the mills on the brook between could not silence. Inside the room is bric-à-brac, particularly ornamental feathers dusty with canary seed. The breeze softly lifts the light wooden frame of a mirror on the wall. As you jerk the cord, sirens are screaming in the harbour, tugs scurry and hoot, white figures below labour with sacks of flour while, above, smoke rises straight and blue from the black volcano.

The tune changes. . . . Sometime the old men sat upon the mountain, each upon a stone seat. Their heads touched the blue sky. Night clattered on in valleys below and over night's invisible back a portent leaped. Another darkness, a cloud of ashes, overwhelms the feeble day. Some jump from terrace to terrace; from vineyard and from vineyard, mothers round up their children, moving like Hecubas; while

below upon the lowest road the fire of the dying sun draws scarlet
bands about the feet of fugitives, is now extinguished by dust, now
clutches at a cart upon whose frame winnowing petals open . . . a cart
among the rain of ashes and overtaken women bundled into fantastic
attitudes: a cart, on and on, carts piled with toppling bric-à-brac
crowned by sobbing children, by basket and spring that last saw the
full light of day strong in the early market: on and on to the sea that
rises from the bosom of a gully ahead like a gown that opens its velvet
grasp and leaves the shoulders bare. Cruel, even sea, you throw no
rescue ropes. Uprooted olive trees festoon the road as it rocks. Light
of this last day is butchered by lava and steam: yet, every now and
then, a bloody ray of seared sun-fire shoots among the fugitives.

 We survivors, as we approach the gully, look back and there, sure
enough, above the black of the earthquake and of the vapour, above
the well-established night that glows red with illicit warmth, the old
men sit agleam against a blue sky. In this cursed double night they
still possess the day. Surely we wake to their tomorrow when at dawn,
stiff after dead sleep upon the deck of the rescue ship, we pluck the
morning air and search with sudden glance the shimmer of the cold
and velvet deep. . . .

 It is noticeable that not only were these fantasies provoked by sound
but contain in them the projection of a great deal of noise. Even the
scenes of my early childhood sustained their life through movement,
the circulation of traffic. Where there is movement there is noise,
and from the noise we fashion images of movement.

 In our urban life, sound qualifies *visually* scenes which otherwise
are confusing and meaningless to the eye. What the eye alone might
perceive is inhuman to a degree. The arts today concerned with
interrelationship of sound and movement, particularly ballet, are able
to draw upon a wealth of life-giving fantasy which in one form or
another is common to millions.

 Thus, the barrel-organ did not restore in the fullest sense the
visual world for me. Such was my anxiety and consequent ambition
that it could be satisfied with nothing less than an instantaneous,
silent manifestation, independent of sound and of a dramatization of
the passage of time: a happy co-existence, then, of things in space

after the manner of mensa the table. It is possible, following an older habit, that the intrusion of sound will still provide a *point d'appui*, but it will nevertheless be serving an entirely different effect.

As the train came out of the Mont Cenis tunnel, the sun shone, the sky was a deep, deep, bold blue. I had half-forgotten about my table for more than ten years. At once I saw it everywhere, on either side of the train, purple earth, terraces of vine and olive, bright rectangular houses free of atmosphere, of the passage of time, of impediment, of all the qualities which steep and massive roofs connote in the north. The hills belonged to man in this his moment. The two thousand years of Virgilian past that carved and habituated the hillsides, did not oppress: they were gathered in the present aspect. At the stations before Turin, the pure note of the guard's horn but sustained and reinforced the process by which time was here laid out as ever-present space.

We arrived at Turin in the late afternoon. There was a change with a wait of half an hour. On a low platform in the clean electric space—shadowless, it would seem—I stood enraptured. I watched the sky between the trains and the edge of the huge gradual curve of the station roof. The sky was now a paler blue but was still close, like the near sound of trumpets.

Day gave way to night without misgiving. Soon, in the new train, it was entirely dark. Although for the last hours of the year, the air was soft, tender, a darkness as of a perfect-fitting lid. After dinner in the restaurant car, most of the passengers had left, the table-cloths were removed. On the other side of the gangway, one table ahead, I again saw the mensa table. Not the plain deal table, it is true. But two Italians sat there with instant faces. Between them in a fiasco was the wine, and to my ears they talked like Romans. Their warm precipitation of life sustained, as it seemed to me, by the glowing reflected light of thousands of sunlit years, banished memories of Hyde Park. Instead of the Serpentine, I saw the Mediterranean, the end of my journey. In their eyes I read the pleasure of house-tops and of different levels.

We were in an electric train. While we stopped at Genoa, I could imagine a giant taut city above the Mediterranean. A young man with a red scarf escorts his sweetheart to the train. He is ugly, but he, too,

holds in his eyes the pleasure of the house-tops and the different levels; of alleys between towering painted walls that float in the shade like goldfish in the sunlight.

The train began to move through Genoa. I could see through the many lighted windows of clear-shaped tenements. In every apartment, I felt, there is this happy evening return, a state of the night which is sheer acquisition; in which, like the men in the train, the inhabitants take up the night by expending the strength of a Latin day. Their talk is now the balustrades, the terraces, the balconies spread out upon the harbour, the radiant open places of the town. The ebb and flow of conversation, still more, of gesture, reconstruct the thoroughfares. As the train glided on, more and more peepshows appeared at every angle to the line. The inhabitants had no need for blinds: since no dominant misery and no surfeit of unexpressed emotion lurked inside them, there was nothing beyond the houses to be shut out.

Meanwhile in a straight passage the train was passing houses on every level to the line, now above them, now on a level with the second storey, now at the foot, now crossing a great viaduct. I had the sensation of passing through the inside as well as along the outside of the houses: never before had I been so much at home. There was every kind of light, perhaps a darkness except from the windows, perhaps a lit campo with ever-bustling happy trees tenacious of root, silent and soft, or a terraced garden with an easy iron gate and steps upon the prospect. There was a conspiracy abroad of universal triumph informing even the roads, the pavements and the harshest stucco. And when we stopped at stations beyond Genoa, at Nervi for example, and finally at Rapallo, the air held scents of flowering trees and of eucalyptus enclosing and disclosing the villas mounting on their gardens. I drove in a carriage through the town to the pension. Echoes of the horse's hooves upon the cobbles brought with them from the walls a sensation of their diurnal brightness. At the end of the ride, the horse was walking up a steep incline through the garden to the pension, a large Riviera villa set behind a balustrade. The scents intensified: there was the sound of waters falling to the sea. Church bells began, and then rang out from every side, from overhanging levels as well as from distances; swift, hammering, light bells. It was midnight, the new year.

On waking in the morning I saw through the open French windows, over the top of a russet-red villa with green shutters, the Mediterranean, the place-name of our civilization. There was a revealing of things in the Mediterranean sunlight, beyond any previous experience; I had the new sensation that the air was touching things; that the space between things touched them, belonged in common; that space itself was utterly revealed. There was a neatness in the light. Nothing hid or was hidden. Soon, an electric train passed, gliding with ease on the hard way just below, entered a tunnel. Unlike the electric trains on London's metropolitan railway which had always been a disturbance, this train and the tunnel did not prolong themselves inside me. It seemed that for the first time things were happening entirely outside me. Existence was enlarged by the miracle of the neat defining light. Here was an open and naked world. I could not then fear for the hidden, for what might be hidden inside me and those I loved. I had, in fact, incorporated this objective-seeming world and proved myself constructed by the general refulgence. Nothing, for the time, lurked, nothing bit, nothing lurched.

As I think now of that valley at Rapallo that goes up to Mont 'Allegro, as I think of the afternoon winter sunlight, I have the sensation of a sound which contains every note, prolonged, entirely sustained, as good beneath as above, a sound that provides every aural want; at the same time it is itself the epitome of complete realization. Nature spreads and mounts before me, fixed and growing, changeless in the clearness of its cycle. I have here the means of action, a demonstration, not of the purpose of life but of the power of life to be manifest; not of one thing but of the calm relationship of many things, concrete things, each bound to each by an outwardness that allows no afterthought to the spectator: an outward showing goes within him. An answering life wells to the surface, and he feels—hence the great beauty of Mediterranean landscape—that the process of a man's existence is outward, giving shape, precise contour to the few things that lie deepest; whatever the distortion they mutually endow, making the expenditure in terms of a surface we call expression, be it in action, art or thought.

The outside world, our own bodies, other people and material things point the goal of outwardness. The Mediterranean scene invokes the

universal aim. In adult life, my models have been things rather than persons.

But whatever the degree, whatever the distortion, all men impute themselves to their surroundings. The broad distorted aspect of the innermost informs every particle of the huge outlying space.

Even a sense of duration or succession discovers itself occasionally as a simultaneity, as forms arranged in space. I do not think that a more direct account of my relations with people would reveal as much as this sparse account of a contemplative relation with the external world. Doubtless it is a proof of neurosis. It determines, however, without prejudice, the aesthetic aim to cause surroundings to describe matters less immediate, perhaps, but often more profound than are revealed by reminiscences; further, to illustrate (given the biological essence) that the human process is aesthetic in so far as it is outlined against the beckoning outwardness of the external world.

Of course it is basic human relationships, above all, that my two landscapes describe. Hyde Park is especially a destroyed and contaminated mother, Italy the rapid attempt to restore. In their terms, and it would seem to me in their terms alone, could I re-create succinctly the division, the incorporation of opposites.

Rapallo could not *oust* Hyde Park. After some years, however, I was to find a direction; but not at once. I had, in fact, a huge commentary with me on that first visit to Rapallo, of Kant's *Critique of Pure Reason*. I used to take it on mountain walks. For several more years I was engrossed entirely in the absolute which I had encountered compulsively first in religion and then (no less compulsively) in ethics and philosophy. After the Rapallo experience the problem had always been 'how to bring the distant things near'. This phrase recurs in many note books. In view of the superlative absolute, how was any preoccupation to be justified? I could not defend myself against the absence of a logical answer. Over and over again everything of value was taken away, ruthlessly, sadistically; even the Rapallo experience.

Meanwhile an interest in art, especially visual art, developed the import of a reliance. I found a period which expressed the Rapello aesthetic of life, the rush to make inside things manifest as a superlative space. When examining early Renaissance architecture and

sculpture I at once recognized this passionate aim. I formed an aesthetic devolving from this art: bit by bit I was reconstructing the good mother amid continuous ruins.

Fire, slaughter, sunlight, rain: the major conflict went on; in London especially. Was there 'objective' justification for the hopelessness I felt in urban life, in suburban life, in polite or semi-polite country life; justification, I mean, warranted to every civilized person who, for one reason or another was not equipped with adequate defences? And what did the more normal man pay for his 'adequate defences'? I doubted, and I doubt, whether the material by and large of ideal inside things are to be easily found outside in terms of modern cities, or whether this outside can easily be converted to suitable inside nourishment.

However, the confrontations with which this book is *ultimately* concerned are as little as possible particular to individual conditions, even to current work or activity. Around objects as they are used or worked, or which accompany stress of any kind, a keen fantasy life is woven. This range, tinged with habit, possesses a contemplative side. But as far as the visual world at large is concerned, it is possible that after childhood most minds only rarely have the opportunities, in particular of solitude, of detachment, of suitable leisure, to step consciously on to a more intense imaginative plane. There remains, however, a low hum of insistence recorded in turns of speech, in gesture, even, and in all folk-lore, in all language.

I shall be attempting a generalized confrontation, however personal the reference; even, at times, an abstract setting of the mind over against the visual world.

The broad confrontation for me, particularly at Rapallo, is the piled-up darkness of the mind with the vast sunlit tangible world. To fantasy, there are as many things inside as there are outside. It is one reason, surely, why we are often appalled by the mere immensity and confusion of the outside world, by a casual or callous aspect; why we are reassured by the beauty and order of things.

A contemplative mood in some surroundings discovers an otherness that is tenuous compared to the Mediterranean. Here in Cornwall, for instance, I sometimes have the feeling that what I see

out of my eyes is a projection of pictures in my head as if I were a cin-
ema reel and the outside world a screen on which the film is pro-
jected, put in movement and enlarged.

In contemplating objects, the degree of outward orientation
varies continually. I have had the sensation, very likely when travel-
ling in Switzerland, that the railway line is piercing a man-made tun-
nel; while passing through a forest, that it is piercing the inner
recesses of Nature whose undergrowth I can to some degree pene-
trate with my eyes. Not so, when travelling through a forest in
England. Orientation to the landscape is different. I have not seen
the track to be piercing a forest. The trees are little more than
scenery to the track, backcloth to my propulsion. When walking on
the track, the country is properly pre-existent. But the carriage in
which I ride makes a little outside world which takes precedence in
the sensation of actuality, even when I am staring out of the window.
I then inhabit a substitute house and I view the country almost as
something which passes this house, like a lorry seen from the den-
tist's waiting-room or a cloud apprehended through the window at
breakfast.

Present circumstance generally forbids the wider relationship
with the object. Every contemplation of the world outside must have
a context, must entail a projection from inside. It still remains true
that such contemplation has an increased scope so far as it is depend-
ing upon a greater apprehension of otherness; upon an *exact* concate-
nation in the outside world.

Sometimes of an evening in a narrow marine street a concen-
trated salt air blows over a wall; it is as if the very cobbles, not the
waves, were hissing. These strong airs are warm, a lighted doorway is
firm and open. Both air and noise blow round incessantly, are never
stale. Indeed there is a calm and a freshness inter-allied, a temperance
of wild air that gives some meaning to the word 'eternal'; an embrace
of ferment as sleep should be.

As well as things in themselves, a wood, a house, the sea, are also
symbols of physical and psychological states; fairly constant symbols;
though qualified by each context, each apposition. Poets are their
chief interpreters: but from some good painters, especially from the

non-literary good painters, we possess also an imaginative statement of space and its objects, of the outside world *per se* as the thing that stands over against the self.

If we were to be shot or hanged within the hour, how fine and untroubled the landscape. We should feel that the ruthlessness within was already dead; or at least expiation was about to be made. And so, the exterior world would lean for us lovingly: we would feel of Nature only the wide embrace. Hitler, the slums and shipwreck would be dead in us: they would no longer qualify the landscape. How finely, how unattainably *out there* the world would look. Unattainably? We shall attain the state out there, the state of complete object, the very brother to stone, all too soon, all too completely. . . .

In the ordinary circumstances of life it is the artist, as much as the scientist in his different way, who in this sense gives full imaginative value to the otherness of the outside world. There, as an independent and more lasting structure, as soundly related form, are the basic inside figures and motive powers both physical and mental. The emphasis, I repeat, is upon the otherness of these forms and of their structure; upon their independence, at least in the greatest visual art. Even though he embraces them, the artist wills to get behind both immediate appearance and immediate fantasy or image thrust upon the appearance.

So-called ordinary people rarely contemplate in aesthetic fashion. They are unwilling sufficiently to disconnect appearance from present circumstance. It is said that the drowning man sees his life outside him as he dies. Similarly, all of us have felt that we have seen an environment 'as it really is', only when under sentence to leave it, when it is no longer part of our concern, a house or a room no less than a view.

The well-known place when we are leaving it, lies close to the eye. Previously our thoughts about it have been tinged with specific matters; previously, in comparison, there was a distance between us and the thing: previously the place had appeared neither as near nor as objective. When we first arrive, still more when we leave, those are times when we 'see' the place in which we live. Waiting for conveyance to the station after ten years' stay, with nothing whatever to do except to wait, we see the room and we may feel upon us all that has happened there in terms of wainscot, wall, light and disposed fur-

niture; we see it coolly as something independent which no longer waits upon our actions. Outside, a row of tulips is not at all a cycle of the cares of cultivation. In a manner more intense than has been possible before, we note the intervals and rhythm of their positions: we may view our life in that place in terms of their upright calm. Such contemplation is near the artist's contemplation. We see ourselves, between two cycles of action, rooted in the soil of our lives.

This wide concatenation of the outside world is more aesthetic, less passive, than those refreshing moments in which we are primarily astounded by the powerful extent of Nature; in watching a sunset, perhaps, or the fury of the sea upon rocks, or the action of submerged rocks, free to the air between waves, for ever and for ever in that brief moment throwing off the maximum water before the return of the wave. Through all the sensations of vastness and of superhuman force and rhythm which such a scene gives to the senses, surely we attend a parable of inner economy, of those forces within, seemingly foreign to us. We are looking on Nature, but at the same time we look on a clearer distribution of forces within ourselves, a clearer interaction, one more Homeric, more in style and therefore more disinterested than is the case. We would that inner conflict were thus windswept, that visitation of the deeper caverns of the mind were subject to such causes as those that govern tides. And indeed they are, though it would take each of us all our years to trace such tidal movements in emotion, such governance by the few essentials. In terms of strength and space and necessity and freedom, a mental no less than a physical reminder bestows for us stark grandeur in the scene. We belong to this immense cradle of life.

In life we substitute, we repeat, we magnify, we complicate, we substitute, we repeat until the whole world is subsumed under our consciousness (childhood's world was smaller). In the course of life we embrace more and more the character of the outside world, giving ourselves to it, taking it within. At death, we and it are indistinguishable.

The more obvious process of living is a giving forth rather than a taking in. Living is ceaseless expression; ceaseless substitution, the putting of one thing into many forms both of action and of thought; the infinite ramification of a few themes. And so, in the more profound contemplation of our lot, we may look upon the truth within in terms of an outside ramification, the exquisite arrangement of space.

And Art? It will already be obvious that it is here regarded as the epitome of this central process.

We have our ways and means of keeping things alive: we forget nothing; and the deeper sources of our feeling are tapped by our environment, by material objects as well as by the human objects with whom we repeat original relationships. The external world is the instigator of memory: the external world reflects every facet of the past: it is the past rolled into the present. Projection, then, continuous and various projection, is the distinguishing characteristic of man. Animus (of how many kinds, infinite in gradation) impinges upon every look, every remark, every unspoken and spoken thought. Above all, as we regard what is external, ourselves speak there.

How blessed that things do not move with our thoughts. The glass on the table is still while I think, imagine, fear and love. A little contemplation of its outwardness, a little scientific or aesthetic appraisal, stabilizes the world short of the need for action or mere physical engrossment. If it were not for the still spatiality and tangibility of this glass on the table, expression would not be our life-blood: at least, not with the colour, already apparent in the process of perception, of abstract, shiftless ideas. It is truly said that the church was founded on a rock.

Boxed up, I leave the house for the harbour. The world expands: there is a sense of freedom. Yet this larger world contains my previous thought. Anxiety, for instance, so far from being blown away on the free air, may be enlarged as it fixes on vast natural agencies. I note the rebutment of the sea by the rocks.

The evening becomes corporeal with strolling tourists. Amid a crowd's taking of leisure, contemplation of a patch of water, a break-water, the side of a house, includes my longest questioning. They are dramatized by the strollers as by music. It is then that I drop my thought into the uninhabited water. This delving is upheld lightly amid the ease of the evening crowd. Deeper contemplation sinks out of sight yet still belongs to the scene in the way that a dog belongs, fathomless in animality, yet genial in the possession of a master strolling on the front. . . .

Consciousness is a brisk dream of the unconscious within: the dream of utmost substitution or distortion, made vivid, made real by continuous contact with the actuality of the not-self: in this way it contrast with the real dream state.

Yet even vast spaces are informed with our feeling, with images, maybe, of our own insides. A film of *Les Misérables* shows once more the sewers of Paris. The hero, pursued, squanders his failing strength carrying the girl, foundering in the subterranean mud and cataracts, in the slipping silky waters of dirt. Many the dangers from this tomb of suffocating, purposeful yet silent water. His head submerges. The vast under-waterway, with its occasional arches, with dim lights from above, holds firmly on the imagination, magnifies, indeed intensifies, images of the inside of the body.

There can be no agnosticism today in so far as we have ceased to formulate with any ardour those metaphysical problems to which agnosticism was applied. We do not deal in unrelated essences. Nor, at present, can any inevitable insistence be given to speculation upon the ultimate relationship of the inner and outer object. Existence, to the modern contemplator, may be observed afresh at *any* point. New peaks, new ranges, have been discovered *inside* man; new seas. The exploration only begins and will make small headway through the barbaric country of the modern world. Blind to the new vista, new religions, chiefly political, flourish on every side. It was to be expected. The unconscious is not misnamed. It cannot be enough emphasized, especially to those who have an interest in psycho-analysis.

I say this after a seven years' analysis.[2] Over and over again, something about which there did not seem to be the vestige of strong feeling, after layer upon layer of extremely cunning, masquerading resistance has been undermined, showed itself to be a centre of the strongest emotion.

We are far more nearly aware of what is unconscious in the minds of other people than in our own. The unconscious is not entirely misnamed: yet this vast acrimonious territory makes itself felt at every moment: our conscious minds are vessels on the seas of our unconscious. Facets of the motivating powers are strongly reflected in the external world. Analysis reveals the unconscious

without the distortions of a glass. But distortion is the very mode and matter of conscious life, the very property of mind and of all that distinguishes us from animals. In terms of projection, in terms, as it were, of the external world out there, the undimensional acuteness of original feeling is given a length, breadth and depth, taking manifold forms in all the activities of man.

There is an intense subtlety at the service of an intense crudity.

Everyone at some time or another must have been astonished in encountering a letter, say, or the result of some action that is theirs but which awakens not the slightest remembrance. As a rule there is some flicker of remembrance, but occasionally you can only accept the fact that it is your own handwriting. Generally you see that although you have forgotten about writing this letter, there is no reason why you should not have written it and forgotten about it. But occasionally, you feel that you could not have written it because it expresses some sentiment never yet entertained, a sentiment not in character.

The greater part of the situations which have determined the main channels of our love and hate and sense of guilt, are forgotten in this way, though they survive to direct our lives. For all the blaring echoes, there are many cries to which we are normally untuned. Yet so vast is emotion, we come to feel that cries from the heart rebound to us from the astronomical distances of the universe.

We are today better able to understand that much thinking, hitherto respected for a connexion with the search for truth, is prompted by the desire to 'keep up morale'. This activity is not to be despised: we all must find ways of keeping up morale, but it is no longer necessary to confuse this search with the quest for truth. An essential characteristic of the future intelligent man will be his power to discover even more satisfying methods of bolstering up his morale without interfering with truth, whether it is the truth as far as it will be known concerning the external world, or himself or others, or concerning political and economic situations: not by banking on dilemmas, for instance, in science or on questions that are insoluble because they are meaningless, in general by rationalizing some wish-fulfilment as

the truth; but by rationalizing some wish-fulfilment as fantasy, by imagination, by acts of love, by art.

In using the word 'morale', I mean the overlay and employment of aggressive tendencies for the hope and theory of what is constructive, in line with the love instincts: in short, a guard against destructive impulses and despair. This guard is essential: but need it deflect the grasp of reality even at the point where it might seem to be dangerous? The grim side of reality threatens *our* reality not because it is grim, but because that grimness, it is feared, might link up with, and assert, our own inner grimness. Our misfortunes remove dust from forgotten inner figures of persecution. Inner life is almost inextricably blended with external events: to reform the world seems easier than to reform oneself.

Nevertheless I think a great deal can be accomplished by honest thinking. Fantasy satisfactions will not be one whit less honourable for being called so: idealism of every kind will have a sure basis. In truth, it will be a great blow against the slavery of the mind, against stupidity.

'In its search for genuine goodness (material) and in its fear of being deceived, this age of "realism" may have overshot the mark; there is reality within us as well as without, the facts not only of our ruthlessness and greed but also of our need to love and be loving, which we suppress and do not honestly avow.' A quotation not from a religious advocate but from a book by two psychoanalysts.[3]

From the heritage of Freud we may begin to understand the long and intricate history of our love and aggression, the springs of all our lives: we can begin to understand what is most needful for our children in their initial and all-important struggles with themselves: and if, owing to no more than average capacity of love allied to a successful emotional economy, we are strong in the power of love, in the constant warmth from our inside archetypal figures who in the outside world have given love and received our love: if we are of those who are no longer so much as children that fear deep in themselves the suffocating, burning, choking omnipotence, the unrestrained power of resentment and of aggressive impulse, then today we may have the means to improve upon the perfunctory denial of primary aggression, perhaps as a form of illusion or perhaps as a sinful fault of structure, that has so imperfectly served civilization. This instinct is

an inevitable component of life. We need it for self-preservation and for the element of attack consistent with any activity. If men, in the light of available knowledge and in the release of their love due, it is to be hoped, to happier upbringing in better conditions, if men allow necessity to fantasy but eschew indoctrination, admit that love's antagonist, except to the eyes, maybe, of fantasy, is no mere extraneous devil, they are likely to tear away many more injurious disguises and denials that involve also the denial of love, to harness with increasing success aggression's palpable, primal, inescapable force and thus gleefully to compel it to greatly enhanced productive uses.

We would have to recognize that many forms of aggression, envy or sour-grape denial, for instance, are modes as well of covering up fantasies of inner hate and rottenness, of reaching out for inner riches at any cost: that the lust for power has this for taproot. All evil actions own an aspect of flight from a condition which is felt to be a greater evil.

Not that a true knowledge of the depth of hate and of the mechanism of hateful thought and action as being also an attempt to preserve love, not that such knowledge can directly help the individual in avoiding these hateful mechanisms or enable him to possess satisfactory means of feeling good inside. Every spiritual economy however unsuccessful, of the sane and insane alike, is already organized to that end. But there exists small understanding of this necessity for the other person and it is very apparent what a difference in the well-being of a child a degree of such understanding on the part of the parents can make. The best hope for the future is in the happier children of more balanced parents, the only cumulative way of a vast amelioration.

Intimations from the soil and from the sky, brought along a warm wind, are also images of the within. Hitler, too, and all the crises are within us. And I see bare trees rising from a rhododendron grove like certain paramount forces from the mind. They are what is evident and of the day. They are extraordinarily clear. They are images of the mind's aspiration, of the mind, the image-fabricator.

To paint a picture is metaphorically to take things to pieces in the outside world and to put them together again; a re-enactment of an early state, since the child is bent upon just such a putting together of what in fantasy he has destroyed, bitten or torn to shreds. It is likely that this

element of reparation underlies all forms of art-making as well as other kinds of 'constructive' activity. Historically speaking, the most usual manner in painting of reconstituting an object has been to create an image of the object, to recreate the object in terms of an essence rather than of a literal appearance. This is the manner of all conceptual art. A further development, in European art especially, has been to reconstitute the image more directly in terms of appearance, even of the momentary appearance due to a particular light. This is perhaps the more adult mode of organization, a greater adventure for the creative faculty in which it may well be lost; just as artistry is so often lost by children as they grow up and attempt in their drawing a greater fidelity to appearance. In the worst traditions of naturalistic painting, the image-making nexus, essential to any work of art, is entirely, or almost entirely, lost. For, such painting entertains a *preconceived image of the appearance*, involves a tricky, shoddy treatment of appearance without an image except the one which is conventional, everyday, inartistic.

Trains, shunting, trains. How the trucks knock, knob and jostle one another. I lie high up, in a hot bath: the vast window is open. I feel this experience acutely, the shunting and rearrangement of trains in the early morning, particularly while I myself am immobile, attentive: the rearrangement, re-shuffle of passenger and freight for further long striding journeys, impinges deeply on the mind. It is a residue, an echo, this shunting, in the concrete or physical form of externality down there in the cold, clear air. To me an echo, it might be taking place in the sky which is all I can see from the bath: a strange yet characteristic inversion. The echo intimates something solid, definite—I don't want to catch my fingers between the buffers—while the original is a fantasy buried deep in the mind.

We are always making up new trains within, near-unconsciously pitting different urges, different personified figures against each other with the hope that they will (with careful shuffling) draw each other along a dominant line. We are perpetually trying to manage, to harness the figures within.

It is to be wondered whether in the pre-industrial age there was a common experience from the external world that echoed the inner shunting to anything approaching the same degree of clearness: how

greatly man's understanding of himself is promoted and limited by an environment merely offered to the senses or whether the invention of the steam engine, for instance, was made in man's image no less than was pre-Copernican science. How far is the external world today outside due correspondence with the inner world, and if it is, what is the cause? The spiritual import of the external world, in so far as it is qualified by the industrial revolution, still lacks interpretation. The spirit has taken kindly to the mythology allowed by railways: but otherwise, movement of the mind does not find easy direction in the world today where man has altered the appearances of Nature: at least, not as well as of old, though there are several exceptions.

Modern cities fight the mystery of the seasons and themselves receive wounds. Here in England is a nameless care in a moderate climate. Electric bulb! What an extraordinary juxtaposition! Nothing is more sudden than the switched-on light. One moment darkness, the next the radiant stare of a glass eye, brilliant, fixed, without incandescence. The dome of the bank fills with holiness at dawn. Space and measurement are diluted by oil and candle-light: in the flicker of a flame a door rears the head of portal. Night rushes on still faster as she enters the mouths and caverns that quiver on the wall. But in a cage of wire the electric bulb does not wink. At the mouth of a gusty tunnel it illuminates a white patch around which dust is blowing. The steady moon rides the night. The sore that throbs by day is soothed when pressed against the white rind of the moon; it does not bridle or pulsate. But what is this fibrous, non-pulsating electric light in the mouth of a gusty tunnel? Like a crane that cleaves the night air, we are waiting. We cannot yet humanize (such is the process of all image, of all correspondence between inner and outer) the electric light.

We begin to do so, just as with trains, with some of the older inventions, more in terms of their noise: whereas correspondence, I think, was previously obtained primarily in visual terms. Certainly, much that is specifically modern is often horrible without its noise. We are entire strangers to Oxford Street in the two minutes' silence. Plastic interplay of noise and movement gives some meaning to contemporary environment. Hence, I have suggested, the great topical content in the art of ballet.

The tons of a tram, each massive screw and indifferent bolt, the violence of unwieldy compression, this painted swan of iron and tin,

feathered with screw and scraper which waddles down two frozen rivulets of steel with boulders packed between; half swan, half centipede . . . such images may occur when a tram is heard to pass, when the challenge is heard of this monstrous bulk to the brazen soil, as if the iron-webbed wheels had a mind to worm a way through the crust of the earth, as if the earth took up the challenge, thrust out a gritty hand, raised the taut leviathan so that he bumps and serpentines without resilience upon a palm of jagged stone traversed by veins of steel.

A perception of power comes to us very largely in terms of movement and sound. Much machinery, at rest, makes an inconsequent impression. Machines, for the most part, work or they break down. How different from the sailing ship.

But what does one expect of university towns? Only puffed clouds rolling over the scenes of former sophistry, over night alarums in crooked streets.

Along, along, along a road. May hedges still meet far ahead. Green and white the well-spread trees. We are speeding in an angled cockpit. There are slow bumps; they seem to touch, to revolve delicately the tenuous hands of the dials upon the dash-board. It is as if the passage of smooth wheels upon a smooth road in a well-sprung car was for this purpose; a transference of power, typical of machinery, ending in sensitive points as a final response: so typical that I see the car ride thus: I see thus the hedges and trees of May, the ancient house, the glowing redness of roofs; and I see Nature's machinery in man designed for the end-result of a registration of desires upon the quivering dials of consciousness.

Science, the more fructifying line of knowledge or speculation, is hard to face where it impinges upon the current beliefs of society. Obvious instances are the Copernican revolution in astronomy and Darwin's theory of Evolution. We have now reached the most difficult line or road of truth: the Freudian discoveries lead to an estimation of the nature of man which at first sight is far harder to bear. Every unconscious resistance is likely to be mobilized against it. Were this road widely used and accepted, truth thereafter would

never be 'awkward': in other words, the pragmatic approach to truth would be identical with an abstract search for truth. Indeed, it is my belief that, apart from better 'living conditions', only this line of truth can increase an emotional equilibrium in men. Myth will abound no less, but let it abound as myth, as poetry, as art by which the spirit lives: in greater purity, therefore, with greater freedom than in culture hitherto. The fire of enthusiasm lies with the state that engenders it, with the aesthetic and practical uses to which it is put, not with the universality of the notions thus engendered. Fantasy has an aesthetic 'truth', defined by and defining scientific truth. This interdependent relationship will become the ultimate object of contemplation. Far, far more will be allotted to fantasy than was suspected in any previous age; in ages far less notable for science, for their grasp of reality. A paradox. Fantasy now becomes more pure as impartiality becomes more pure. Love and life cannot be ousted. They will grow yet warmer in the hearts of men when the dusty embers of universal systems based upon partialities and compulsions are raked out thoroughly.

The essence of man's cultural development has been a gradual submission to, and control of, reality, resulting in an increased sub-stitution or a complicated deferment of emotional outlet. On the side of thought, man has rationalized neurosis and compulsiveness in terms of many speculative systems and religions; a kind of prose-poetry, detrimental to the purer prose of science which brings in its wake a purer and more voluminous poetry. If we recognize substitu-tion as the basis of all human activity, we endow living with aesthetic values. *Art never quarrels with science.* Viewed as activities, at many points they approximate: viewed as expressions of truth, they define each other.

Part II

FROM THE TRAIN ONE SEES away in the middle distance at the top of a field in a corner, some small, rounded trees. The warmth imputed to them is fleeting, yet even so we pass out of sight rapidly. It will be cold at night in this corner of the field as well as desolate.

Clear voices of boys sound hard and deliberate against the continuous rapid language of the train. Couplings, woodwork creak: the sounds suggest a forced smile upon bloodless lips.

The rounded trees are now far behind: an agony belonged to their mute, primrose-like, immobile appeal, against the sky. The muteness is shot at by the noisy pulling back of a gritty corridor door, by a thump of steps, a great deal of peering. 'Hullo, Stokes, what kind of hols?'

The tempo quickens as the train slows down for our destination. We boys are all in black: our grins are tigerish.

Or else it is the earlier, shorter journey to a prep school. These boys are smaller, whiter, with little of the crescendo of a sprouting life. The smell of the station is profound. There is a criticism from other families in virtue of their mere existence: they are ladders to the great desolate hard self-rapture of the world beyond one's own.

Under the blare of King's Cross almost every boy is led by a parent far along the platform to be sick, sick from frightened anticipation, in front of the train that will throng him on an iron journey.

London drags out along the route; against the will it begins to thin: less and less people live here as if a curse lay on the glowering land. In the semi-country at Barnet we stamp our way over a bridge that clatters; we take brake for the school. Masters are with us, a matron awaits. There will be a fire-practice tomorrow. . . .

To confront such deadly journeys, to serve as the Rapallo to this Hyde Park, we shall recall Cézanne in the year 1886 or so, travelling from Paris to Aix-en-Provence (seldom to return), exchanging the swift seasons of the north for a panorama he made immovable.

First, however, it will even assist us to remember the summer wind through the plane trees of London as an invisible yet palpable wasting of time, as the hustling away of wares among which the buyer, through straining with a complete lack of indifference, could not decide. This warm wind strikes chill; the music of leaves is not heard except as an accompaniment to the ominous sound of steps upon the pavement, steps that pass, that carry with them and disperse

an attempted concentration of thought. Trees of London are the harbingers of a footfall, the trees of the squares, lofty, towering, slightly swaying, the trees of the parks, the trees of the streets.

And yet, in the moment when the heart expands, rustling pavement foliage demonstrate the omnipotent powers of desire, of the compelling spirit, towering, expanding, embracing chimney-pots that have withstood so many winters. A pulsating life-blood would appear to warm the very spire of a church. Magic then belongs to movement and to repose: their division, their occasion, demonstrate the parts or attitudes of a universal breathing.

From such romantic antiphony, I, at least, pass gladly to consider the classical achievement of Cézanne, a deeply emotional, and yes, romantic, temperament. It will be found that in so doing and in reassessing shortly this painter's development, I shall have preferred my theme finally in the matter of art.

We picture him, then, on his way to his homeland which was his work, part of his work as surely as if he were a farmer. This was the way of his excitement. It could be called an obsession; in which case we would have to adapt his words about Monet and exclaim: but what an obsession. He, Cézanne—and we consider only his southern landscapes—was partner to the Provençal countryside. He sought to 'realize' his 'sensation', as he called it, in painting after nature: he sought tirelessly, starting at dawn, for the essential lie of the land. This meant in his case an enormous expenditure of a powerful inner fire, all ferocity, all love: for these, as is the way of life, he found an object; as is the way of art, a useless object, an epitome of the life-process. He transmuted his strength, pushed it further away from himself than has any other artist, into a living-dead thing, into a Cézanne-become-a-landscape. For, remember, it was his 'sensation', no mere semblance of the countryside. He cut the chord with his fancy; the picture substituted his considerable ferocity and his remarkable love in terms of a grandiose yet razor-fine logic imputed to the outside world. His was the most direct homage ever paid to the infinite coherence of the visual world.

He strove to find for his canvas neither a tendency nor an echo of a mood, a waxing nor a waning: he strove for his senses to reveal, for his mind to recreate, a quintessential structure. And so he hurried away from all the incidental music of things. Yet Cézanne's painting cannot

be called a conceptual art, for it is with the extreme complication of actual, even momentary, appearance that he philosophizes. The observational truth of light, space, colour, tone and mass in their subtlest, no less than in their generalized, modes, are the sole materials of his structure. The otherness of the outside world is affirmed, not mitigated, by the intrusion of this artist's organizing mind. His art needed a constant exercise in observation, for each new canvas a forcible detachment from the preconceived; endless thought, endless vigilance for every inch of the picture space. There was discouragement, timidity, self-distrust. But, for once, it is not agonies of mind that point the moral. Cézanne wrestled alone with the Provençal landscape, and his vision, which did harm to no one, yet sums all human activity.

And surely we may learn here of further ways to peace of mind. If when the senses are fully employed a contemplative mood supervenes, searching for interconnexion, for a form, for a dominant note in this other, laid-out world beyond the body, we realize that in these terms of outside things—and we must not allow them to lean to us: they must preserve a perfect otherness—deep elements of all experience are observed and enjoyed. There is a submission to the factors of existence. Thus does a man breathe in a fresh morning. All men exercise an imaginative control, an imaginative limitation over their environment, enclosing as best they may a small world in accord with the needs of satisfying desire. But an unabashed aesthetic control (which so many thus rule out by enforcing conditional limitations) does harm to no one, depends for its sense of omnipotence upon no rationalization of prejudice, projects fantasy as fantasy, aggressive and loving, attaches a most noble imaginative logic to sensation, and, by affording so deep a sense of fitness, may allow the mind, if neurosis[4] be absent, to be free for impartial thinking at every point of reality.

May it come to that, if leisure for all will be unlimited: after an era of supreme vulgarity will have given way to a deep reliance upon more vivid uses of the mind and senses: when works of art, epitomes of all contemplation since they derive from contemplation of the face of concrete things, will be valued at a greater worth.

Cézanne withdrew from the concourse, withdrew very largely from Paris after 1886, withdrew from his friends particularly in his last twenty years. Perhaps the concourse in many more millions will come to him. He discovered a poetry that is without afterthought.

'I have nothing to hide in art',[5] writes Cézanne to Charles Camoin in 1903: and, 'What shall I wish you: good studies made after nature, that is the best thing.' Two years later to Louis Leydet: 'To succeed in formulating sufficiently the sensations we experience on contact with this beautiful nature—man, woman, still-life—and that circumstances should be favourable to you, that is what I must wish to all sympathizers of art.' Two months before he died in October 1906 Cézanne wrote in a letter to his son: 'I am sorry that I am so old in view of my colour sensations. . . . It is unfortunate that I cannot make several specimens of my ideas and sensations; long live the Goncourt, Pissarro and all those who have the love of colour, representative of light and air.' A month later: 'Finally I must tell you that as a painter I am becoming more clear-sighted in front of nature, but that with me the realization of my sensations is always very difficult. I cannot attain the intensity that is unfolded before my senses. I have not the magnificent richness of colour that animates nature. Here on the edge of the river, the motifs are very plentiful, the same subject seen from different angles gives a subject for study of the highest interest and so varied that I think I could be occupied for months without changing my place, simply bending a little more to the right or left.' In the same month to Emile Bernard: 'I am always studying after nature and it seems to me that I am progressing slowly. I should like to have you near me for the solitude weighs rather heavily on me. But I am old and ill, and I have sworn to myself to die painting': as he did less than a month later.

In Cézanne's last letters, particularly in the letters to his son, the reader is struck by the constant juxtaposition of small requests and observations on nature or on painting. We realize that the lie of the land obsessed him, that he worked out his life there: not only in the manufacture of paintings but in front of the landscape or still-life, in his sensation before the object. But to estimate his achievement one must consider what he, for the first time in landscape or still-life painting, resisted in the object once he had settled to painting it: for instance, one must think of the low reminiscent murmur of wind among trees, along hedges; of slow thought among mounting land; of the passage of water; of soul-searching or else lyric mornings, of wrapping clouds: in effect, of the moods and evocations that we all have from nature to some degree, Cézanne by no means least. It has been said he painted portraits

and landscapes as if they were still-lifes: indeed, he could resist as far as possible the seasons. Where are the voices of the fountains of Aix or the roystering yet ghostly Mistral blowing out of a blue sky; where the shuttered liquid peace of a calm Provençal afternoon? Neither in what we know of Cézanne's mature aims nor in the treatment of his subjects do we find any desire to reflect discursive messages from nature. And yet to visit Aix is at once to recall his pictures, to view them as an astonishing, faithful, mirror of that countryside, not only of the lie of the land but of the feel of the air, the character, the 'life'. It will then be no surprise to discover that Cézanne's youthful letters to Zola reveal an adolescent and a young man of extreme romantic temperament, of fervent poetry, whose roaming and bathing in his native landscape had become the centre of imaginative life. This landscape remained there, at the centre of his life. It is more true to say that his portraits and still-lifes are Provençal landscapes; while the many canvases of male bathers, particularly of the early middle period, as well as from the Louvre, from Rubens, from the Venetians, from 'Poussin after nature', derive from the passionate aquatic displays and the first freedom of the three inseparable youths, Cézanne, Zola and Baille.

Although we emphasize Cézanne's sense of structure, we must, then, also emphasize how close was his impact with nature; that at first it was a stark, even primitive, romantic onset in relation to his subjects, hinged to a Baroque complication, a Baroque posturing. His primitive simplicity, after emulating the counterpoint of Baroque design, subdued this element, especially in the early middle period, to the ends of a rectilinear grandeur that informs every inch of a painting's surface. Under the tutelage of the Old Masters whom he studied, copied and emulated all his life, particularly the Venetians, Rubens and Poussin, under the influence of Pissarro, under the influence of the deeper meaning of his native southern province, his love of Virgil and the classics, even perhaps of his own Italian ancestry, a romantic onset than which none more wild or savage or honest in primitive directness (yet from the first always subtle in counter-balance) had yet appeared in visual art, was miraculously enlarged with a majestic consensus of calm and even factual sensation; so that in spite of his lifelong devotion to the art of Delacroix and of his denigration of Ingres, Cézanne's work stands to us as one of the greatest achievements of classic art; at any rate in one sense—and that perhaps the most dynamic—of the

word classic. When we attempt to clarify the ultimate intention, Van Gogh, for instance, is found to stand at the opposite pole.

Classicism in the sense of a truly Mediterranean art, while keeping the broad grasp and the dignity associated with the wider use of the word, is 'close to nature', far closer than is a great deal of romantic art which treats of nature as a raw projection of emotional states, of the inside man. This classical art springs from a precise love and a passionate identification with what is other, insisting upon an order there, strong, enduring and final *as being an other thing*, untainted by the overt gesture, without the summary treatment, without the arrière pensée of 'thinking makes it so'.

How then did this classicist who insisted so fiercely upon the otherness of the spatial world, behave if he opened his heart when out for a walk? Gasquet's account of the lonely ageing artist whom he so passionately admired—such admiration had taken the shy and rejected Cézanne entirely by surprise—is probably a broad effect: even so, it is the text to which we feel entitled. 'He drank in the countryside with delighted eyes', wrote Gasquet; the countryside that he studied every day. 'The first pale leaves moved him deeply. Everything touched him. He would stop to look at the white road or to watch a cloud float by overhead. He picked up a handful of moist earth and squeezed it to bring it closer to him, to mix it more intimately with his own reinvigorated blood. He drank from the shallow brooks.' Earlier in this account of a walk, Gasquet wrote: 'He regretted that I was not a painter. The countryside thrilled us. He showed me, and explained to me at length, the beauty of all his conceptions of poetry and art. My enthusiasm refreshed him. All that I brought him was a breath of youth, a new faith that made him young again.'[6] It is easy to see that Cézanne was recapturing the original sense of those diurnal rushes at the landscape, with the youths Zola and Baille, which had so largely determined the channel of his life. Let the reader at once juxtapose an image of his painting where he translated this tender and ferocious pagan impetus into voluminous form. Nothing more conceptual as well as nothing less constructive seemed worthy to him.

Cézanne clung closely to nature. It is not said with the implication so familiar in art criticism today that at this one point the arch-revolutionary could not free himself, that here by a last divorce lay

the best chance for his successors. It is said with the opposite impli-
cation. The validity of his abstraction, of his distortion, even,
depended initially and continuously upon his emotional yet slow,
painfully slow, thoughtful, consideration of mere appearance *qua*
mere appearance. A sudden or conceptual management of appear-
ances was entirely alien to him. Vollard, in describing the 115 sittings
he gave Cézanne for his portrait which was left unfinished, remarks
on the great proportion of the time spent by the painter in looking at
the model. True, he went on with the portrait without the sitter but
only, it becomes obvious, when he felt able to carry in his head a vast
concatenation of appearance relationships. But not one touch would
he put on except in reference to the whole, that is to say, in reference
to his vision of what he wanted to subtilize as well as to abstract and
emphasize in the whole. This construction, as one might call it, was
a simplification of what the artist deemed to be the essential appear-
ance, rather than an image substituted for a variety of appearances,
which is the way of conceptual art. It has been possible for subse-
quent painters, while preserving something of Cézanne's classicism,
to cut out the long agony, indeed, to impose a summary concept or
image upon the object. Such achievement, though sometimes it
would appear closely related to Cézanne, is in many ways at the
antipodes. A super-imposed pattern of the object, though it rely
upon less distortion than was employed by Cézanne in formulating
his plan, may still bear no resemblance to his respectful use of an
object. No artist looked harder and longer at the model. The only
'truth' he would recognize in his scheme was a concatenation of rela-
tions that corresponded with the infinite pictorial elements of an
actual appearance. He was, of course, by no means a slave to the
model; but that is not to say that in his search for the appearance
behind the appearance he was prepared to simplify a form, unless it
be to elaborate contingent forms or contingent spaces.

Conceptual art of all degrees has its great masters: but it is
impossible to bring Cézanne within this fold. Indeed, he took no
interest in primitive or archaic or formalized art; which is remarkable
to the student who is aware that in his posing of figures, for instance,
there was often an insistence upon a simple, primitive and even naïve
attack which was a part of his great strength that he never forsook, a
prerequisite of the subtilization and the synthesis he performed.

Here, first of all, he was most original: in view of many of his successors, he would appear yet more original in not being contented with it; for, his subtilization and complication in no way mitigate or detract from this first simple onset: they indicate not a retraction but an enforcement.

He abominated in painting the unbroken surface whether in the earlier masters or in the paintings of Gauguin who at one time professed himself Cézanne's disciple. Cézanne would have nothing of it and Bernard says Cézanne 'spoke very harshly about Gauguin whose influence he considered disastrous'. When Bernard protested mildly that 'Gauguin admired your painting very much and imitated you a great deal', Cézanne replied furiously: 'Well, he never understood me: I have never desired and I shall never accept the absence of modelling or of gradation; it's nonsense.'[7]

If we remember Cézanne's omnipotent, almost *fauviste*, flourish in his early bohemian days,[8] if we consider what he 'worked through', it is easy to understand his revulsion from Gauguin and from the use the post-Impressionists made of his achievement, whose dismemberment he would naturally regard as disastrous. Perhaps the later letters with their emphasis upon studying after nature, reflect this same revulsion. Nevertheless, if we wish to learn more fully from Cézanne than have many of his notable successors, it may at least help us if we turn to these last letters,[9] most of them to young admirers, in which he expresses the sum of his artistic experience: and we shall find that the emphasis is in fact by no means where the Cubists chose to find it.

Thus, in May 1904, he wrote to the young painter, Emile Bernard: 'I go ahead very slowly, as nature appears very complex to me and incessant effort is required. One must look at the model carefully and feel very exactly, and then express oneself with distinction and power.'

'The artist should scorn any opinion that is not based on an intelligent observation of character. He should avoid the literary spirit, which so often leads the painter astray from his real mission, the concrete study of nature—and causes him to lose himself far too long a time among intangible speculations.'

'The Louvre is a good book to consult, but it should be only as an intermediary. The true and immense study to be undertaken is the diversity of the spectacle of nature.'[10]

It was a wonderful balance Cézanne held between what he called 'intangible speculations' and the acceptance of nature as most complex, with a complexity requiring a continuous observational effort. The letter which has these phrases succeeds the famous one written to Bernard a month earlier in which he said: 'May I repeat what I told you here: treat nature by the cylinder, the sphere, the cone'; those words which, rather paradoxically, became the text of Cubism. But putting the two texts side by side we more nearly glimpse his whole achievement, especially if we add a sentence from one of the last letters to his son: 'I felt well there yesterday; I started a water-colour in the style of those I did at Fontainebleau, it seems more harmonious to me, it is all a question of getting as much affinity as possible.' Cézanne did not baulk the extreme complexity of nature, a far greater complexity than the Old Masters allowed; he learned to organize it and in so doing to 'obtain as much affinity as possible'. This last phrase elucidates the character of a modern classicism,[11] how it is possible to modulate—Cézanne's own term—in a way more contemplative than is the one of the romantic, often slap-dash, sometimes successfully slap-dash, approach, how it is possible to modulate into pictorial terms the great variety of sensation from the object.

I shall be returning to more general considerations. First, a few more passages, among many, from Cézanne's letters in which he asserts the primacy of direct study of nature. To his son he writes in September 1906: 'I am sending you a letter that I have just received from Emilio Bernardinos, one of the most distinguished of aesthetes. I am sorry not to have it in my power so as to infuse into him the idea which is so sane, so comforting and the only correct one of the development of art through contact with nature. I can scarcely read his letter, but I think he is right, though the good man simply turns his back in practice on what he expounds in his writings; his drawings are merely old-fashioned rubbish which result from his dreams of art, based not on the emotion of nature but on what he has been able to see in the museums, and more still on a philosophic mind.'

To Emile Bernard, October 1905: 'Now the idea to be insisted on is—no matter what our temperament or power in the presence of nature—to produce the image of what we see, forgetting everything that has been done before. Which, I believe, should enable the artist to express his entire personality, great or small.'[12] In September

1906: 'You must forgive me for continually coming back to the same thing: but I believe in the logical development of everything we see and feel through the study of nature and turn my attention to technical questions later; for technical questions are for us only the means of making the public feel what we feel ourselves and of making ourselves understood.'

If we have this reiteration in mind we shall not misinterpret what follows in a letter to Bernard of 1904: 'Literature expresses itself by abstractions whereas painting by means of drawing and colour, gives concrete shape to sensations and perceptions. One is neither too scrupulous nor too sincere nor too submissive to nature; but one is more or less master of one's model, and above all, of the means of expression. Get to the heart of what is before you and continue to express yourself as logically as possible.' Again, the word logic. Cézanne felt strongly that he did not force the model: he enunciated its logic. The classicist object, an object, as it were, with full rights of its own, must possess an intense logic or coherence.

Finally, nine days before he died, in a letter to his son: 'The weather is stormy and changeable. My nervous system is very weak, only oil painting can keep me up. I must carry on. I simply must produce after nature; sketches, pictures, if I were to do any, would be merely constructions after nature, based on method, sensations, and developments suggested by the model, but I always say the same thing.'

Cézanne was proud to reiterate a conscientious dependence upon immediate appearance. At the same time, for each motif he would, he insisted, find the essential logic: that first and last and with every stroke between: in these terms, he knew, would pass all the 'literary' content, all the mystique, the passionate visions, the pantheistic identifications which he had felt or associated with his motifs. After all, it is only a difference of degree between this classicism and the romantic expression, a sudden sum of experience wherein there exists the very gesture to prove the fire is hot, the vision vivid.

Nevertheless, I am pretending that there is a problem, how it was that the second kind of expression should give way to the first. I want to know how it could come about that Cézanne who in his youth was the first wild man of modern art revelling in an orgiastic omnipotence, should also have insisted with such an expense of agony upon the object as pure object, upon pushing the apple away from himself. His

progress was always steady and he gave nothing up: his later expression does not reverse but includes the furious aims of the earlier.

After some attention to Corot the real influence was Courbet, the first genius of the new classicism; while the influence of Delacroix whom he loved was with him throughout his painting life. But soon the influence of Impressionism, of 'the humble and colossal Pissarro', was decisive, and in more ways than one. In the light of his contemporaneous figure compositions, it seems probable that Cézanne's conversion to Impressionism coincided with a renewed study of the Old Masters, particularly the Giorgionesque (not only on account of Manet's *Déjeuner sur l'herbe*) as well as the later Venetians. The link between the Venetian and the Impressionist styles would have been a more subtle and a more pervasive poetry.

The momentary appearance, then, the Impressionists' object, this new red-hot material for art, in Cézanne's keeping above all, came to serve a vast and timeless pictorial architecture. Not only for Cézanne but for all that group of artists, the concentration upon momentary appearance meant, as it were, surrender of all its rights to the object. A new poetry flowed freely, not to clog this objectivity but to pervade an acute exaggeration of the otherness of everyday scenes most evocative to our feeling.

But why was the former poetry not enough, even though possessing right from the start pronounced classical elements, why the drive within Cézanne's fiery, romantic disposition to refuse warmth from his pungent fires in favour of a less assertive, even if smokeless, heat? That is our pretended problem which we shall seek to solve for the sake of wider issues, though not in terms of psychology[13] but in terms of aesthetics.

We have under examination a headstrong lyrical impulse—it found no final satisfaction—which, in development, sought with ceaseless urgency a comprehensiveness, a detachment that evoked the most vital sense of the term, classical. We may compare it with an expression at the opposite extreme, a mere arrow in the air or a handful of clay appropriated and fashioned into an anthropomorphic presence. We may consider for a moment the imaginative projections of men with scant leisure, scant horizon and rough circumstances. Working as a trawler-hand, with beard and icy fingers, fumbled with heavy clothes, fish-smell, dirt and close quarters, not

even the life-long artist can produce an aesthetic state without a saga. Possibly a religious, mystical or a rhythmic state that depends from some dramatic culmination. But he cannot, except flippantly, push away from him the heaving pile of struggling live fish nor gaze at it for the quality of otherness, nor thereby construct an expression to demonstrate the external world with the finality, the calm assurance of a dispensation as when on homeland, evening light removes weight from the sky, lends this weight to things.

No: such contemplation needs a caress from nature: not necessarily a softness but a coherence, a stabilization, a clarity which will provide a frame for even the harshest experience, for the peasant life, maybe, which Cézanne knew and loved. Thought has wanted the same condition for its nurture: it is no accident that the Mediterranean countries are the nurseries and the halls of factual thinking no less than of our classical art, whatever the sense of classical. When we speak of science in opposition to fantasy, we but mean impartial thinking freed of fantasy, an impartial thought which in its first days dared to find that the sun rose on a new day as a result of physical law rather than because the devout had prayed for it to reappear.[14] And so, while it is an expression of fantasy no less than romantic art, the order of classical art is less personal, an order, as it were, of fantasy facts, rejecting the wistful beauty of a fantastic and tremulous dispensation. Classical art in Europe, before it has encountered the terrible menace of polite conventions, of a mechanical pompous rule, delights to ring with pagan amplitude the contorted movements of the imagination, delights in a gusto, in a warm exuberance that pours as if from the wider apertures of the natural world. This art, then, at root, is deeply wedded to the consciousness of fact and, as we have seen, to logic, seeking to win for imaginative expression the objectivity or otherness of the factual world, to win for fantasy, for life, the exhaustive finality of death. It is the position of all art: classical art formulates the aim.

Thus our so-called problem in this case clarifies before the Mediterranean scene to which Provence belongs. With all his temperament, with all his terror of everyday problems, with all his emphatic fiery genius, Cézanne's attitude to art was catholic. Though mocked as a madman, in his thought and in his practice as an artist he exalted sanity.

He, too, experienced the openness of wine. Art for him was not a matter of intimations. What is the intimation of a blue day? There is a

calm and a wide arrangement, clean spaces between things, clearness, clarity, light. We see it in England only perhaps on a still, early autumn afternoon of brilliant sunshine when the stooks and all the disposed colours stand: a biblical scene. On a blue day a song is given to the wide panorama: it is less a provoked fancy than a background or dramatization of what exists. Nevertheless, folk art everywhere is a slow extraction from the cycles of labour and country-scene, like a slow northern anger. Romantic art is fantasy speaking in terms of things: but in the south, things as themselves are captured for the mind. They have all weathers and all conditions: yet the blue day conquers.

Just as the great movement of the sea washes through our minds, so the lucidity of a still day attributes to the mind a pillared hall.

I have used the art of Cézanne to descant upon a continuous relation between emotion and the outer world. A stress on any point or points of the line of this equivalence (divided roughly, very roughly and artificially into the two zones, classical and romantic) determines both the quality of an artist's emotion and the kind of object he selects. The terms, especially outside historical Europe, have little meaning apart from a context. They are without precision and express as an antithesis what is in fact a gradual differentiation. They are, however, indispensable because by their means we can sometimes characterize broadly the artist and his object.[15] Though our concern is wider than specific art, they were introduced in order to illumine the equivalence where it is best acknowledged.

Like the difference between these two terms, so the difference between art and life is one only of degree, if living is conceived as the multiform of expression. Artistic expression or communication is self-sufficient in comparison with the interlinking activities of life, of which art is the useless epitome. We need but to refer to another truism—a work of art is a communication in terms of the data of the senses—to point to a certain rivalry here with the exposed otherness of the external world. Not only is a work of art, as a datum of a sense or senses, an object in the literal meaning, but that object expresses the universal desire to translate life into an outward attachment. The libido, according to one aspect of Freud's metapsychological thought, is primarily object-seeking.[16]

Some investigators discover in the ego a dread of being over-powered by instinctual forces *per se*. The ego as an organization, it is said, fears the unorganized. Thus, the ego (life itself, a physicist[17] tells us, is but intensified molecular *organization*) would seem to involve a consciousness that is more than a filter between the external and the internal. Management of instinct by the organizing ego which employs conscious thought, would seem further to involve the frequent enforcement on instinctual drives of a ramification, a projection, a substitution, culminating in culture.

Some such line of thought gives a rationale for man's ceaseless substitutive activities; interprets, for instance, the value we so often attribute to the expressing of one thing in terms of another, the value of art.

When all else of the night is black and when deep longing encounters a stretch of glimmering moonlit sea through trees, we experience in epitome the calm delirium of consciousness: as in adolescence, perhaps for the first time, not only speculative thought or abstraction but the starlit sky afford an apprehension of otherness dressed with the apparel of our passion; when the world becomes enormous and is matched by desire.

In differing degree, artists preserve the essence of this first wider rapture no less than they hold to the child's compulsion to project immediate but enclosing fantasy upon outside things.

If the two-thirds at least of the world's population which has never been properly nourished will be as well fed as the remaining third, if efficient social services and universal education are no dream, if leisure is to be almost unbounded, will art obtain the worth in a settled life that more than once it has had for an aristocracy? In the end, perhaps; and sooner if the controlling ego will be able to accept the vastly improved spiritual economy of an allocation between fact and fantasy wherein a great deal more is allowed to fantasy. But whether or not such values develop soon, it would appear that the aesthetic activity epitomizing all activity, this play which is sublime, will enrol a vast army of new addicts: they will hasten such a clear-cut division of meaning. An aesthetic appraisal of existence does not point to a huge concourse of would-be painters of musicians but to the affirmation in many more activities of aesthetic values.

We of this century have suffered a pressure from reality which finds the spirit of man unprepared: or so it seems, in spite of his creating that pressure with inventiveness. The discovery of atomic power brings to a climax our situation of imaginative unpreparedness for the environment ensuing from the Industrial Revolution. If civilization should succeed in surviving and if unbounded leisure should come suddenly, there would be a problem no less serious than those which confront us now: and we cannot guess as to the character of the equivalence which at a distant date would be contemplated most deeply between the spirit of man and the material of the outside world. (It is safer, at least once, to use this circumlocution for the arts in the future.) The crafts which have nourished them would seem to be doomed. In work the opportunities for art wane rapidly. But whether or not there would be the practice of art as now known to us, in my belief the aesthetic approach would eventually invade all rationalizations except those of science which define it.

At the moment, the heirs to a potential magnificence move among the many tortured, starved, diseased, blinded or contorted by toil. After fifty or a hundred years, after an increase of education and social services, we might have been in better condition for this overwhelming atomic gift. It is tantalizing that such immediate danger should occur at a time when painfully, slowly, through the science of psychoanalysis, a beginning is made in the understanding of the nature and economy of man's emotions and of means by which to strengthen the economy. And what if science, biochemical science, develops far-reaching power to mutate the species, while as yet the majority of scientists, like the majority of their fellow-men, need to resist the simple facts of our passions and of the infinite ramification of our substitutions? Shall the species suffer change at the hands of those who, maybe, have a strong vested interest in not experiencing what could be known about the nature of the mental life? It is the duty of every scientist, the fount of power today, to seek psychoanalytic treatment in its longest form.

Such an opinion, a demand for scientists to be yet more scientific, superb as is their tradition, will be considered ludicrous, as well as irrelevant, especially in a book that philosophizes art, by one who is not a scientist: more especially as the final words.

I can only repeat I do not think it so.

N O T E S

England and Its Aesthetes

1. See Arthur C. Danto, "Warhol," in his *Encounters and Reflections: Art in the Historical Present* (New York: Farrar, Straus and Giroux, 1990), 286–93.
2. Arthur C. Danto, "Munakata in New York: A Memory of the '50s," *The Print Collector's Newsletter X*, no. 6 (January–February 1980): 188.
3. Kenneth Clark, introduction to John Ruskin's *Praeterita* (London: Rupert Hart-Davis, 1949), xvi.
4. F. R. Leavis, *The Great Tradition*, (New York: New York University Press, 1973), 2.
5. See Denis Donoghue, *Walter Pater: Lover of Strange Souls* (New York: Knopf, 1995), 179–87; also A. C. Benson, *Walter Pater* (London: Macmillan, 1906), 4: "it is obvious that a certain autobiographical thread is interwoven."
6. The bibliography for *Library Edition: The Works of John Ruskin*, ed. E. T. Cook and Alexander Wedderburn (London: George Allen, 1906), noting no direct discussion by Ruskin of Pater, observes that he was reported to quote Pater in lecture; see vol. XXII, xxxvii, n. 4; a fuller account of their relationship is provided now by Paul Tucker, " 'Reanimate Greek': Pater and Ruskin on Botticelli," forthcoming.
7. *Clement Greenberg: The Collected Essays and Criticism*, Volume 4, *Modernism with a Vengeance, 1957–1969* (Chicago and London: University of Chicago Press, 1993), 75–76.
8. Roger Fry, "Some Questions in Esthetics," in his *Transformations: Critical and Speculative Essays on Art* (Garden City, NY: Doubleday, 1965), 4. Fry's view of politics is presented in his "Art and Socialism," *Vision and Design* (New York: Meridian Books, 1956), 55–78.
9. Immanuel Kant, *The Critique of Judgement*, tr. James C. Meredith (Oxford: Clarendon Press, 1952), 71.
10. Muriel Spark, *The Prime of Miss Jean Brodie* (New York: New American Library, 1961), 72.
11. John Pope-Hennessy, *Learning to Look* (New York: Doubleday, 1991), 3.
12. My own "Art without its objects?," *British Journal of Aesthetics*, 19, no. 1 (1979): 53–62, deals with this issue.
13. Charles Baudelaire, "On the Essence of Laughter," *The Painter of Modern Life and other essays*, tr. Jonathan Mayne (London: Phaidon Press, 1964), 165.

14. Charles Baudelaire, *Intimate Journals*, tr. Christopher Isherwood (San Francisco: City Lights, 1983), 86.

15. Roger Fry, quoted in Virginia Woolf, *Roger Fry: A Biography* (New York: Harcourt, Brace and Co. 1940), 15. See also Louise De Salvo, *Virginia Woolf: The Impact of Childhood Sexual Abuse on Her Life and Work* (Boston: Beacon Press, 1989), 192–3 and Laurie Schneider Adams, *The Methodologies of Art: An Introduction* (New York: HarperCollins, 1996), 214–5.

16. Jay Fellows speaks of Ruskin's "need for 'doubleness' . . ."; see his *The Failing Distance: The Autobiographical Impulse in John Ruskin* (Baltimore and London: Johns Hopkins University Press, 1975), 125.

17. Vladimir Nabokov, *Lolita*, (New York: Vintage International, 1989), 39.

18. "Introduction," *Modern Critical Views: Walter Pater*, ed. Harold Bloom (New York: Chelsea House, 1985).

19. Fredric Jameson, *Postmodernism, or, The Cultural Logic of Late Capitalism* (Durham: Duke University Press, 1991), 9.

20. *The Works of John Ruskin, M. A.: Fors Clavigera* (New York: Thomas Y. Crowell, nd), vol. III, 47–53.

21. *The Works of John Ruskin*, ed. E. T. Cook and Alexander Wedderburn, XVII, 105.

22. *The Works of John Ruskin, M. A.: Fors Clavigera*, vol. II, 129–30.

23. Walter Pater, *Marius the Epicurean* (London: Penguin, 1985), 270.

24. A point made by Richard Wollheim, "Walter Pater as a Critic of the Arts," *On Art and the Mind: Essays and Lectures* (London: Allen Lane, 1973), ch. 8.

25. Mr. Louis Auchincloss has a quite different view: "He liked Victorian England, it suited him very well. His maiden sisters supported him, they gave him an enthusiastic audience. There were no laws that he wanted to break. He fitted in perfectly well." (author interview with Louis Auchincloss, October, 1996).

26. See William Arrowsmith, "Ruskin's Fireflies," *The Ruskin Polygon: Essays on the Imagination of John Ruskin*, eds. John Dixon Hunt and Faith M. Holland (Manchester: Manchester University Press, 1982), 198–235.

27. My account borrows from Heather Henderson, *The Victorian Self: Autobiography and Biblical Narrative* (Ithaca and London: Cornell University Press, 1989), 84–91.

28. *The Critical Writings of Adrian Stokes*, (London: Thames and Hudson, 1978), vol. II, 51, 310 n. 8.

29. Adrian Stokes, *Three Essays on the Painting of our Time* (London: Tavistock, 1961), 45–46; see also the commentary by Stephen Bann, "The colour in the text: Ruskin's basket of strawberries." *The Ruskin Polygon*, 122–36.

30. *The Critical Writings of Adrian Stokes*, vol. 1, 223.

31. *The Works of John Ruskin, M. A.: The Stones of Venice*, (New York: Crowell, nd), vol. I, 212.

32. Walter Pater, *The Renaissance: Studies in Art and Poetry*, ed. Donald L. Hill, (Berkeley, Los Angeles, London: University of California Press, 1980), xix–xx.

33. J. Hillis Miller, "Walter Pater: A Partial Portrait," *Modern Critical Views: Walter Pater*, 75.

34. John Pope-Hennessy, *Learning to Look* (New York: Doubleday, 1991), 78.

35. "Notes of a Journey through France and Italy," *The Collected Works of William Hazlitt*, ed. A. R. Walter and Arnold Glover (London: J. M. Dent, 1903), 190–91.

36. Quentin Bell, *Ruskin* (New York: George Braziller, 1978), 33.

37. Charles Baudelaire, *Intimate Journals*, 38.

38. *Essays on Postmodern Culture*, ed. Hal Foster (Port Townsend, Washington: Bay Press, 1983); Terry Eagleton, *The Ideology of the Aesthetic* (Oxford: Basil Blackwell, 1990), 62–63.

39. John Barrell, *The Political Theory of Painting from Reynolds to Hazlitt; 'The Body of the Public'* (New Haven and London: Yale University Press, 1986), 339.

40. Michael Podro, *The Critical Historians of Art* (New Haven and London; Yale University Press, 1982), xxi. A full history of Ruskin's role remains to be written. Gombrich identifies similarities between Warburg's and Ruskin's ideas in E. H. Gombrich, *Aby Warburg: An Intellectual Biography* (Chicago: University of Chicago Press, 1986(Second edition), 124–5: In John McAndrew's large recent survey history of the Venetian architecture of Ruskin's chosen period, Ruskin has a modest place in the literature as an authority who inspires, still, argumentation. (John McAndrew, *Venetian Architecture of the Early Renaissance* (Cambridge, MA, and London: MIT Press, 1980).) A valuable historical perspective on Ruskin is provided by John Pemble, *Venice Rediscovered* (Oxford and New York: Oxford University Press, 1996).

41. Carol Duncan, *The Aesthetics of Power. Essays in Critical Art History* (Cambridge: Cambridge University Press, 1993), 118–119, an analysis developed further in her *Civilizing Rituals: Inside Public Art Museums* (New York and London: Routledge, 1995).

42. I owe this point to Arthur Danto who, objecting to my complaint that *The Journal of Aesthetics and Art Criticism* has little to say about art criticism, argues "that aesthetics has a reach far wider than the preoccupation with art as such. . . ." (Arthur C. Danto, *Embodied Meanings: Critical Essays & Aesthetic Meditations* [New York: Farrar, Straus and Giroux, 1994], 382).

43. Marcel Proust, *On Reading Ruskin*, trans. and ed. by Jean Autret, William Burford, and Phillip J. Wolfe (New Haven and London: Yale University Press, 1987), 50, 52–53.

44. See my "Baudelaire, Pater and the Origins of Modernism," *Comparative Criticism: An annual journal*, 17. (Cambridge University Press, 1995): 109–21.

45. Marcel Proust, *Remembrance of Things Past*, tr. C. K. Scott Moncrieff and Terence Kilmartin (New York: Vintage, 1981), vol. I, 460.

46. See my "Artcriticism-writing and Arthistory-writing," *The Art Bulletin*, LXXVVIII, no. 3 (September 1996): 401–3.

47. Proust, *Remembrance of Things Past*, vol. I, 48.

Inside Out

1. Cf. *Young children in war-time*, by Dorothy Burlingham and Anna Freud, Allen and Unwin, 1942.

2. Many of those who have had no occasion to look into the matter closely might be surprised, if they did, to find how sickly and often exotic a relation the current talk of psycho-analysis, particularly in many novels or in some apparently authoritative books, bears to the still little known, or rather, little understood, resistance-evoking theory and clinical practice of Freud:

resistance-evoking to the ordinary psychiatrist and to the unauthorized or self-styled 'psycho-analyst' who has not had either the Freudian analysis or training, no less than to the vulgarian amateur psychologist who longs for magic and cheap Mephisto themes.

3. Cf. *Love, Hate and Reparation*, by Melanie Klein and Joan Rivière. Psycho-analytical epitomes No. 2, Hogarth Press, 1937. It seems to me that from such a book made up of twin lectures by two of the most authoritative analysts (based primarily on the researches of the former) and addressed to the general public with marked success, an unequalled amount of insight and wisdom may be gained by the attentive reader. Also, there could be no less confusing mirror of the psycho-analytic approach.

4. Cézanne is reported by Gasquet to have said: 'L'Art console de vivre.' The practice of art is, of course, very often, perhaps always to some degree a personal flight from life, possibly the most successful of all such flights. It is unnecessary for me to enlarge upon this fact which I fully recognize. But it is incumbent on me, therefore, to show that, despite this fact, the practice of art is more widely rooted in life.

5. Except where otherwise stated, the quotations from Cézanne's letters are from the translations by Margaret Kay, edited by John Rewald. *Paul Cézanne. Letters*, Bruno Cassirer, Paris, 1941.

6. Cf. *Cézanne* by Joachim Gasquet, Bernheim-Jeune, 1921. This passage is quoted by Gerstle Mack, whose translation I use, in *Paul Cézanne*, Cape London, 1935. Gasquet's reconstructions of conversations with Cézanne are the source of many of the remarks attributed to him which do not come from the letters.

7. Mack, op. cit., p. 307.

8. At several points I find I have closely followed Roger Fry in his *Cézanne. A study of his development*, Hogarth Press, second edition, 1932, 54 plates. It is to be hoped this masterpiece of criticism is now in print again. It contains among other virtues an unrivalled critique of some of the paintings themselves. [It was reprinted in 1952.]

9. Now available in one volume in English. Rewald, op. cit.

10. Mack, op. cit. His is the more literal and the better translation. For the text of the letters to Emile Bernard see his *Souvenirs sur Paul Cézanne* in *Mercure de France*. Sept.–Oct., 1907. Vol. 69.

11. An infinitude of creation, particularly in the matter of the kind of form that arises from acuity of colour sense, remains to us in 'painting after nature'. Cf. *Colour and Form.*

12. Mack, op. cit.

13. I would bring this small detail to the notice of a future investigator. Bernard (op. cit.) reports Cézanne saying of his father: 'He was intelligent and good-hearted and he said of me that I was a bohemian who would die in poverty if he didn't work for me; and he made it possible for me to do nothing but paint all my life.' I believe that Louis-Auguste was, and thought himself to be, an extraordinary man and that on balance it was his pride to think the same of his son, once that the painting situation had been accepted. One must not forget the portraits and the youthful frescoes at the Jas de Bouffon. Even from the first there will have been some paternal pride in his painting.

This conversation, at any rate, should be put against the presentation of Louis-Auguste in many biographies, as a caricature of the mean and uncomprehending father. Cézanne's struggle with his father has naturally many aspects, not least of which is a love and an identification.

14. Such achievement of impartial thinking could have been won only after a lessening of anxiety. Thus, by an effect here attributed to the 'approachability' of the Mediterranean climate, one is reminded of a mitigation of anxiety through analysis which allows the previously neurotic psyche to entertain less rigid, because less separated and less compulsive, notions: when the good and the bad 'objects', personified within, are not kept apart with such a paramount dread; when the bad is less abysmal, can therefore be faced and fought; when, as a consequence, the good is more genial, less fragile, and the mind is more open to the impact of 'things as they are' as well as to a belief in its own power.

On this point I quote (though not because the colour blue stood to him for goodness and security) from the conclusion to a case-history of a boy of ten who had suffered a deep depression: 'When Richard had become able during his analysis to face the psychological fact that his loved object was also his hated object and that the light blue mother, the queen with the crown, was linked in his mind with the horrid bird with the beak, he could establish his love for his mother more securely. His feelings of love had become more closely linked with his feelings of hatred, and his happy experiences with his mother were no longer kept so widely apart from his experiences of frustration. He was therefore no longer driven on the one hand to idealize the 'good' mother so strongly and on the other hand to form so terrifying a picture of the 'bad' mother. Whenever he could allow himself to bring the two aspects of the mother together, this implied that the bad aspect was mitigated by the good one. This more secure 'good' mother could then protect him against the 'monster' father. This again implied that at such times she was not felt to be so fatally injured by his oral greed and by the 'bad' father, which in turn meant that both he and his father had become less dangerous. The good mother could come to life once more, and Richard's depression therefore lifted.' See: 'The Oedipus complex in the light of early anxieties' by Melanie Klein. *The International Journal of Psychoanalysis*, Vol. XXVI.

15. I have associated our own western conception of classicism with the grasping of the full relevance of fact. Our romanticism contains a certain revolt against fact, as well as against the artificiality of convention, in an insistence upon individual fantasy. Nevertheless, however extreme the romanticism, it cannot, in its nature as art, forego completely the formal aspects. The case of our music gives a very cogent example. The romantic movement of the nineteenth century greatly extended and enriched symphonic form. The plan, the pattern, the organization, those qualities we know of in material so much better than we know of them in the spirit, belong as well to romantic art, even if they are not enunciated with the contentment of classical art. Among the cross-currents of differing styles it sometimes happens, at any rate in Western art, that the romantic disposition *par excellence* attaches itself with the force of a discovery, with a new and vigorous love, to the capaciousness of the classical form; that is, if it be or could be made, ample.

The period of the early Renaissance was of this character and the situation of Cézanne's painting was not far different. Conversely, with a similar fructifying air of triumph, a high moment of romantic conception may become for future generations the classical canon: it is the situation of classical ballet.

16. A more technical presentation of this argument may be found in a short paper: 'Concerning Art and Metapsychology'. *International Journal of Psycho-Analysis*, Vol. XXVI.

17. See *What is Life?* by Dr E. Schrödinger, Camb. University Press, 1944.

Bibliography

Ruskin has been fortunate in his biographers—I have learned much from John D. Rosenberg, *The Darkening Glass: A Portrait of Ruskin's Genius* (London: Routledge & Kegan Paul, 1963); Quentin Bell, *Ruskin* (New York: George Braziller, 1978); John Dixon Hunt, *The Wider Sea: A Life of John Ruskin* (New York: Viking, 1982); Wolfgang Kemp, *The Desire of My Eyes: The Life and Work of John Ruskin*, Tr. Jan van Huerck (New York: Farrar, Straus and Giroux, 1990). I have been aided also by the introduction by Robert L. Herbert to his *The Art Criticism of John Ruskin* (Garden City, New York: Doubleday & Company, 1964). Kenneth Clark's introduction to *Praeterita* (London; Rupert Hart–Davis, 1949) and the notes to his anthology *Ruskin Today* (Harmondsworth, Middlesex: Penguin, 1964) remain valuable. The great scholarly resource is the *Library Edition: The Works of John Ruskin*. ed. E. T. Cook and Alexander Wedderburn (London: George Allen, 1906). I have a real debt to Elizabeth K. Helsinger, "History as Criticism: *The Stones of Venice*," *Studies in Ruskin: Essays in Honor of Van Akin Burd*, ed. Robert Rhodes & and Del Ivan Janik (Athens, Ohio: Ohio University Press, 1982); to the chapter on *Praeterita* in Heather Henderson, *The Victorian Self: Autobiography and Biblical Narrative* (Ithaca and London: Cornell University Press, 1989); and to Anthony Lucy Gully, "Sermons in Stone; Ruskin and Geology," in *John Ruskin and the Victorian Eye* (New York: Harry N. Abrams, 1993).

Pater's biographies include: A. C. Benson (*Walter Pater* (London; Macmillan, 1906); Michael Levey, *The Case of Walter Pater* (London: Thames and Hudson, 1978); and Denis Donoghue, *Walter Pater: Lover of Strange Souls* (New York: Alfred A. Knopf, 1995). I have learned also from J. Hillis Miller, "*Prosopopoeia and* Praeterita," in *Nineteenth–Century Lives: Essays presented to Jerome Hamilton Buckley*, eds. Laurence S. Lockridge, John Maynard and Donald D. Stone (Cambridge: Cambridge University Press, 1989), 125–39, Louis Auchincloss, "Pater and Wilde: aestheticism and homo-sexuality," *The Style's the Man. Reflections on Proust, Fitzgerald, Wharton, Vidal, and Others* (Charles Scribner's Sons, New York, 1994), and the numerous suggestive allusions to Pater in his novels; Kenneth Clark's Introduction to *The Renaissance* (London and Glasgow: Fontana/Collins, 1961); and from Paul Tucker's essays: " 'A Whole World of Transformation': Landscape and Myth in Walter Pater's Ms. Fragment on Corot," *WALTER PATER (1839–1894): Le forme della modernità* (Venice: Le bricole 1. Dipartimento di Letterature e Civiltà Anglo-Germaniche, 1996), 45–80; and "Displaced deixis and Intersubjectivity in Narrative: Linear and Planar Modes," *Journal of Literary Semantics* XXII/1 (April 1993), 45–67. The book of most value is Paul Barolsky, *Walter Pater's Renaissance* (University Park: Penn State Press, 1987).

For Adrian Stokes, the standard edition *The Critical Writings of Adrian Stokes*, ed. Lawrence Gowing (New York: Thames and Hudson, 1978), three volumes is complemented by his *To-night the Ballet* (London: Faber & Faber, 1934) and the essays in *A Game that Must be Lost: Collected Papers* (CheadleHulme, Cheadle: Carcanet Press, 1973). Two collections of commentary are devoted to him: the special supplement, edited by Stephen Bann, of *PN Review* 15 (Volume 7 Number 1); and *Les cahiers du musé national d'art moderne* 25 (Fall 1988), edited by Yves Michaud. The exhibition catalog of his paintings *Adrian Stokes* (London: Serpentine Gallery, 1982) contains much useful information, including a biographical note by Richard Read, who is writing Stokes' biography. The brief discussion in my *Artwriting* (Amherst: University of Massachusetts Press, 1987): 56–70 anticipates the present account.

There is no satisfactory general discussion of aesthetes, nor, to my knowledge, an adequate history. On Roger Fry, Richard Shiff, *"Painting, Writing, Handwriting. Roger Fry and Paul Cézanne,"* published as an introduction to Roger Fry, *Cézanne* (Chicago and London: University of Chicago Press, 1989) is important; and useful information appears in Sylvia Stevenson, "Roger Fry and his Aesthetic," *A Cézanne in the Hedge and other memories of Charleston and Bloomsbury*, Foreword by Michael Holroyd, Ed. Hugh Lew (Chicago: University of Chicago Press, 1992), 41–46. My analysis of narrative transitions borrows from Arthur C. Danto, *Narration and Knowledge* (New York: Columbia University Press, 1985), and the discussion of Baudelaire builds upon my *High Art: Charles Baudelaire and the Origins of Modernism.* (University Park and London, 1996). On the grand tour, see Jeremy Black, *The British Abroad: The Grand Tour in the Eighteenth Century* (New York: St. Martins Press, 1992): 260–75 and Antoni Maczak, *Travel in Early Modern Europe*, Tr. Ursula Phillips (Polity Press: Cambridge, 1995).